Fashion Illustration Techniques

A Beginner's Guide for Fashion Designers and Illustrators

Hiroko Fukuchi

TUTTLE Publishing

Tokyo | Rutland, Vermont | Singapore

CONTENTS

What Is Fashion Illustration? 4
Materials and Tools 5
Line Differences Using Different Media 6
Pencil Training 7

1 Drawing the Human Body

Human Proportions 10
 Pose Variations 13
 Poses and the Center of Gravity 16
Facial Proportions 18
Hairstyles 20
Hats 22
Arms and Hands 24
Legs and Shoes 26
 Shoe Styles 29
Male Proportions 30
 Basic Facial Balance 31
 Pose Variations 32
 Designing for Men 34

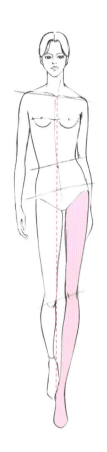

2 Drawing Fabrics and Garments

Fabric in Motion: Wrinkles 36
 Sketching Wrinkles and Folds 38
 Sketching Gathers 40
 Draping 41
Differences in Materials 42
 Looking at Lines 44
Fabrics and the Body 46
Details 50
 Necklines 51
 Collars 52
 Sleeves 53
Other Details 54
 Ribbons and Knots 55
 Fasteners and Accessories 56
 Bags and Gloves 57
 Pockets 58

3

Illustrating and Designing Clothes

Drawing Individual Items 60
 Female Bodies 62
 Male Bodies 63
Skirts 64
 Tight Skirts 64
 Flare Skirts 66
 Gathered Skirts 68
 Pleated Skirts 70
 How to Draw a Skirt 72
 Skirt Styles 75
Pants 76
 Pant Specifications 76
 Pant Silhouettes 77
 Pant Lengths 77
 How to Draw Pants 78
 Pant Styles 79
 Types of Pants 80
Shirts and Blouses 82
 Types of Shirts and Blouses 84

How to Draw a Shirt 86
 Shirt and Blouse Styles 89
One-Piece Dresses 90
 What Is a One-Piece Dress? 90
 One-Piece Dress Design Variations 94
 One-Piece Dress Styles 96
Jacket / Coat 98
 Structure and Details of a Tailored Jacket 98
 How to Draw a Jacket 100
 Jacket Design Variations 102
 Jacket Styles 104
 Coat Design Variations 106
 Coat Styles 108
 Types of Jackets 112
Other Items 113
 Knitwear 113
 Cut and Sewn 114
 Underwear 115

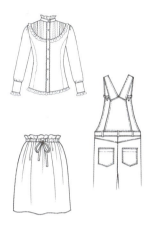

4

Getting Creative with Color

Whiteout Techniques 118
Transparent Watercolors 120
Markers: Features and Techniques 124
Fabric Expression 128
 Painting Materials and Patterns 128
 Thick Fabrics 134
 Thin Fabrics 136
 Glossy Fabrics 138
 Satin, Lame and Sequins 139
 How to Draw Faux Fur 140
 How to Draw Knits 142

What Is Fashion Illustration?

Whether it's drawn as a blueprint for a design proposal or as a finished drawing for a garment, a design sketch, a fashion illustration is the first link in a creative chain of clothing creation. They're the blueprints for the stunning original outfits to come. To create fashion illustrations and sketches, it's important not only to have good drawing skills, but also to understand the basic proportions of the human body and to know the structure of clothing and the materials used to create the pieces we wear every day.

Fashion illustration can have a variety of intentions. Are you creating a look or a line, showcasing head-to-toe full-color designs of outfits that will excite and enthrall? With these renderings, the balance and proportions of the human body are key concerns. The illustration can capture the texture of the fabric, suggesting its heft, drape, and feel. Alternately, fashion illustrations can focus on individual garments, items, or accessories. These drawings are typically of a single piece shown as if it were arranged and placed flat on a drafting or sewing table. These types are illustrations are common in the apparel industry and are used for instructions, specifications, catalogs, and promotional material. The characteristic feature of this style is that wrinkles and folds aren't included, but rather the basic lines are clearly drawn using a ruler. It doesn't give a sense of the materials and fabrics to be used, but it can convey patterns and details more accurately.

This book explains how to create fashion illustrations from the basics, focusing on style, design, and the execution of individual elements. The purpose of fashion illustrations is not necessarily to create beautiful illustrations or stunning original designs. Often they represent the steps and stages in a complex creative process. Be excited about the design you're imagining as you watch it take shape before your eyes. Remember, have fun and free your inner fashionista as you draw dozens of dazzling designs!

Materials and Tools

There are many manufacturers and types of art materials and tools, so find the ones you are comfortable with and feel comfortable using.

▼ **Paper:** Drawing paper and copy paper. It's also good to have a small sketchbook for ideas and trial drawings.

▼ **Pencil:** For fashion drawing, choose a pencil that's soft and easy to use.

▼ **Drawing Pens:** Water-resistant pens that can be used for coloring afterward. 0.5/0.3/0.1 mm pens of different thicknesses are useful.

▼ **Brush Pens:** If it is water-resistant, it can be used for coloring later. Good for drawing intonated lines.

▼ **Colored Pencils:** There are oil-based and watercolor pencils, so match them to your application. Either is acceptable when used for finishing textures.

▼ **Markers:** Twin-type markers have good color reproduction even with a single coat. A larger number of colors can be used for a wider range of expressions.

▼ **Opaque Pens:** Often used for finishing. Can be used to add luster or to draw patterns on top of dark colors.

▼ **Straight Line Rulers:** A straight line ruler of about a foot (30 cm) in length is recommended.

▼ **Erasers**

▼ **Curve Scale Rulers:** Mainly used for drawing items. A scale ruler for dressmaking is also easy to use.

▼ **Neri Erasers:** Useful for leaving a thin underdrawing.

 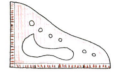

▼ **Transparent Watercolors:** Transparent and can be used for a wide range of expressions, such as layering and blending.

▼ **Opaque paints:** Can be applied in a single coat, and colors can be painted on top of each other. Convenient for painting patterns on top of dark colors.

▼ **Palettes:** Those with individual compartments are convenient.

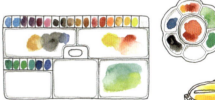

▼ **Cups & Buckets:** Containers for washing brushes, such as unused cups, are also acceptable.

▼ **Brushes:** A soft bristle brush is suitable for depicting water. It's best to have a stiff type on hand as well.

▼ **Soft Pastels:** Soft pastels have a soft texture and can be rubbed to create a gentle effect; especially effective when used to lightly add color to the background of a person.

▼ **Hard Pastels:** Can be used as is, but when ground to a powder with a cutter, it has a similar feel to soft pastel.

▼ **Oil Pastels (crayons):** Sticky texture and water-resistant. Not suitable for detailed depictions, but good for depicting rough knitwear and woolen fabrics.

5

Line Differences Using Different Media

Pencil

Colored Pencil

Drawing Pen

Brush Pen Marker

Marker

Watercolor (Transparent and Opaque)

Soft Pastel

Hard Pastel

Oil Pastel

Pencil Training

Fashion illustration yields a range of designs by simply drawing lines and figures. Begin by practicing with lines of about 4 inches (10.2 cm) in length and gradually get used to drawing longer lines of about 12 inches (30.5 cm) all at once. With pencils, the amount of force applied is easily adjustable, so long lines can be drawn with light force. Another advantage of pencils is that you can add intonation to the line. A mechanical pencil is also useful for detailed drawing, but you should first get used to drawing with a pencil.

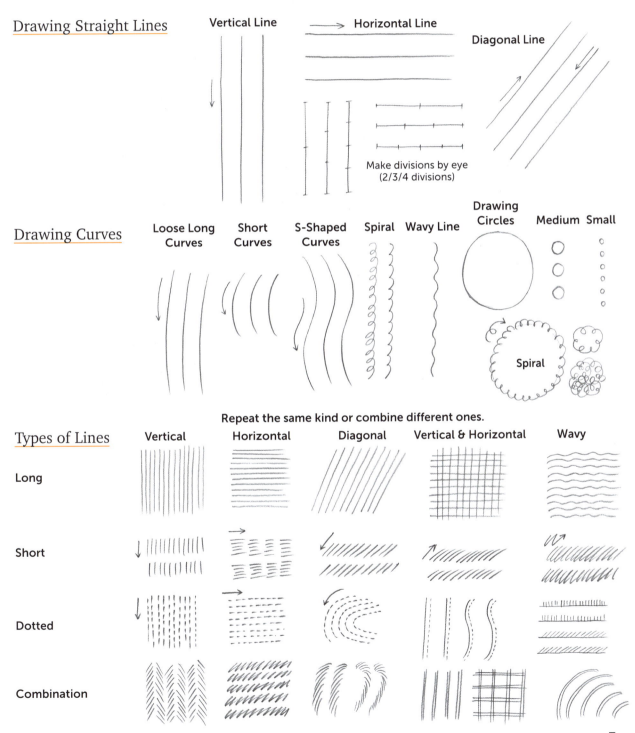

Once you're familiar with the materials and can draw lines freely, it's easy to add patterns!

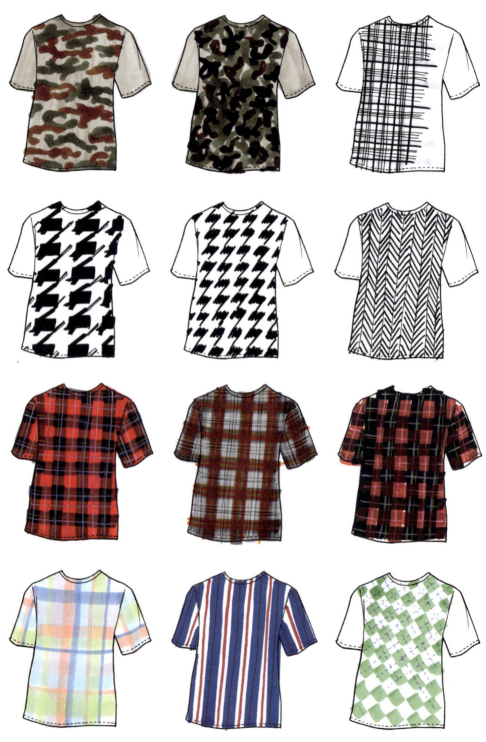

1 Drawing the Human Body

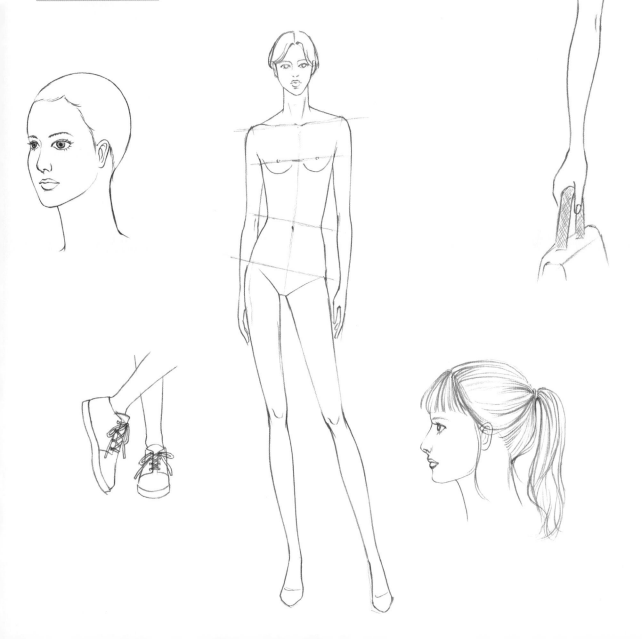

Human Proportions

The human form in fashion illustration is typically depicted with a basic balance of eight heads. That means the entire body is drawn at eight times the length of an average human head. Eight heads are considered to be the ideal balance in order to show designs clearly and effectively.

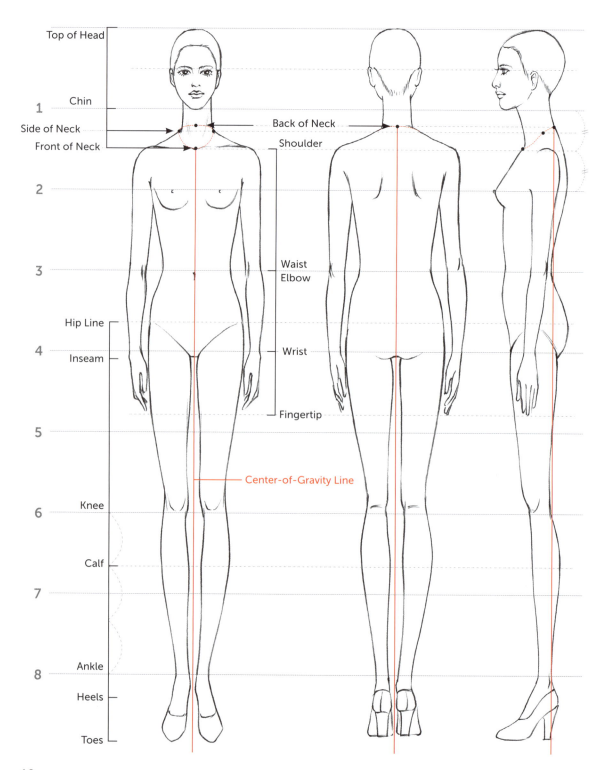

The 8-heads-to-body ratio is commonly used because the height and width are well balanced. The width should not be too thin or too thick. Try applying the following ratio to the face width.

Guideline					
1 = 1 head length	[Front]	Face width = 0.6 times	Chest width = 1.1–1.2 times	Waist width = 0.8 times	Hip width = 1.2 times
	[Lateral View]	Face width = 0.9x	Chest width = 0.9 times	Waist width = 0.6x	Hip width = 0.8 times

Fashion illustrations are not always created at a fixed size. If the size of the paper is different, the size of the whole body is altered accordingly. 1 head (3 cm) on letter-sized paper and 1 head (1.6 in/ 4 cm) on legal- or larger-sized paper are good when drawing the whole body. 1 head (½ in/3 cm) means the chest width = 1.3–1.4 in/3.3–3.6 cm, the waist width = 0.9 in/2.4 cm, and the hip width = 1.4 in/3.6 cm.

Approximate Ratio

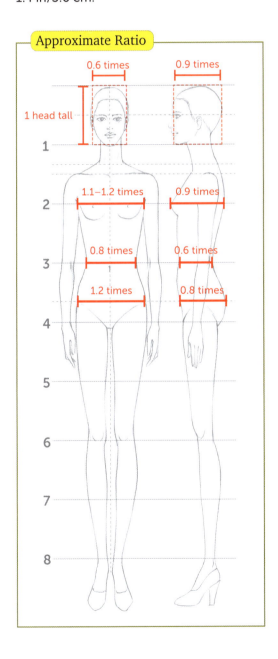

Let's Draw the Human Body

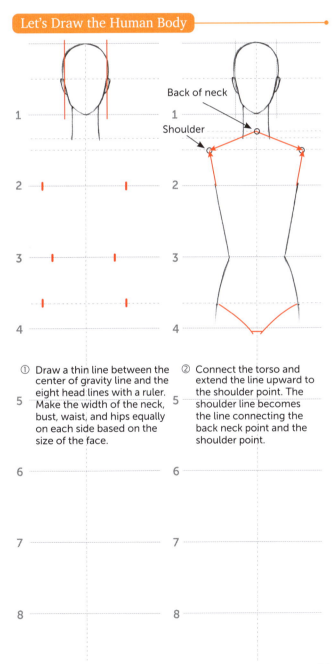

① Draw a thin line between the center of gravity line and the eight head lines with a ruler. Make the width of the neck, bust, waist, and hips equally on each side based on the size of the face.

② Connect the torso and extend the line upward to the shoulder point. The shoulder line becomes the line connecting the back neck point and the shoulder point.

11

③ Draw the arms and legs. Draw straight lines for the length of the arms and legs, and lightly draw guide lines for the joint positions as well as the widths of the wrists and ankles to make drawing easier.

④ Add volume to the arms and legs (details for arms → page 24, details for legs → page 26). Pay attention to the parts that protrude and the parts that curve inward, and connect them with curved lines.

⑤ Draw the hands and feet. Both should be about three-quarters of one head length. Be careful not to make them any smaller than that.

⑥ Draw the bust and navel.
⑦ Draw the face and hairline.

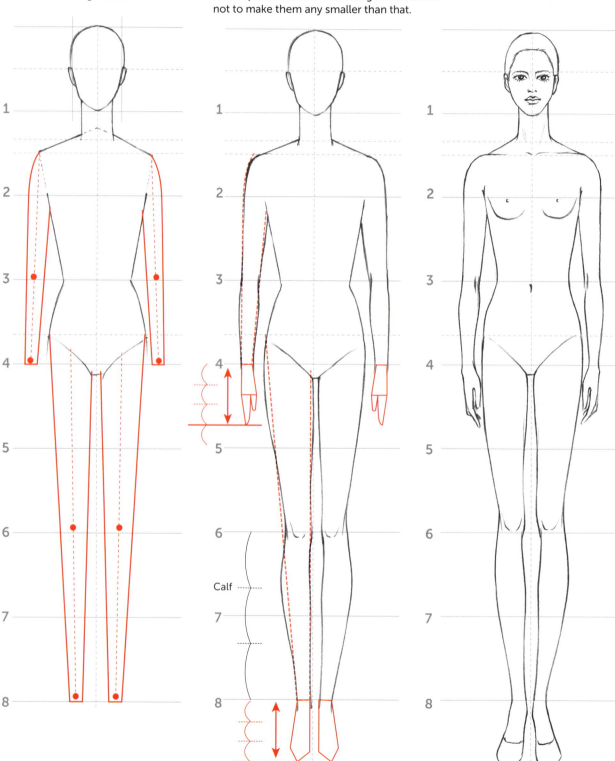

Pose Variations

Basic pose with weight on one leg. Easy to match with various items.

Walking pose. Useful for adding dynamism or showing the movement of clothing.

Arms and legs closer to the center, creating a streamlined look.

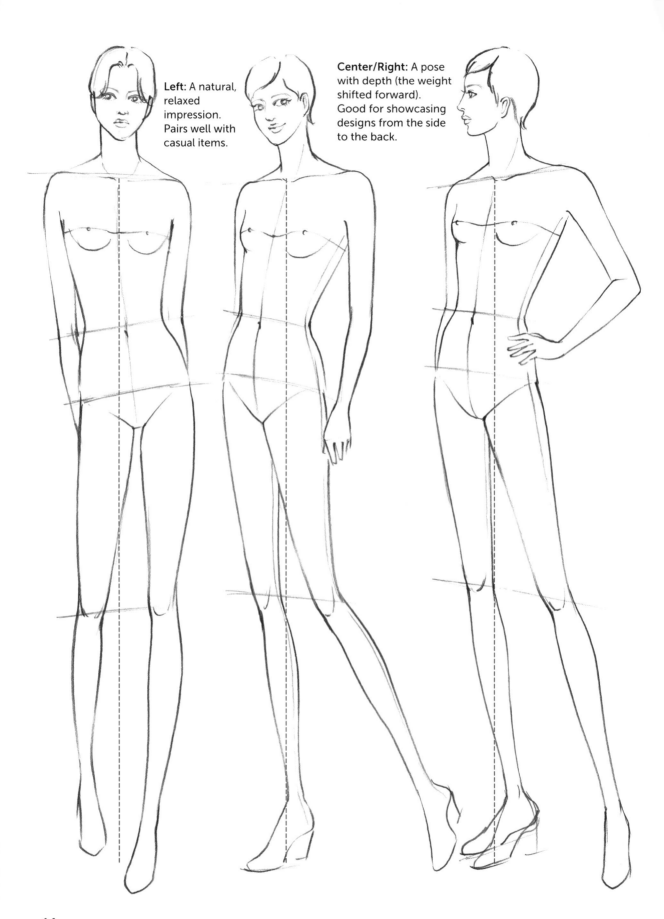

Left: A natural, relaxed impression. Pairs well with casual items.

Center/Right: A pose with depth (the weight shifted forward). Good for showcasing designs from the side to the back.

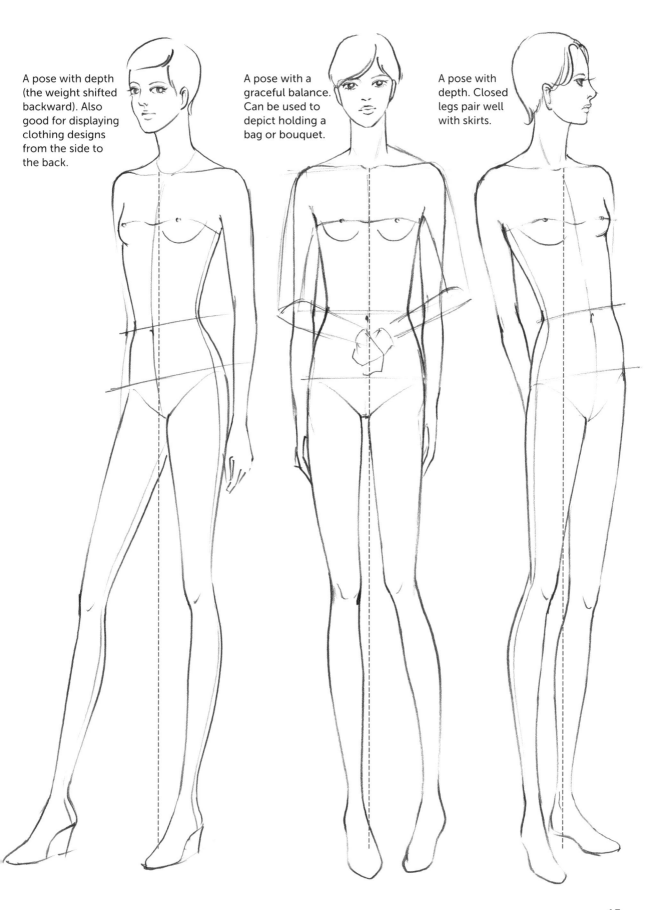

Poses and the Center of Gravity

When drawing a pose where the weight has shifted, it's important to carefully understand the location of the center of gravity. The leg bearing the weight is called the "support leg," and it's crucial to ensure it makes firm contact with the ground.

If you draw a vertical line from the neck, the ankle of the support leg will be close to this center of gravity line. Another characteristic of a one-leg-weighted pose is that the hip on the support side tilts higher.

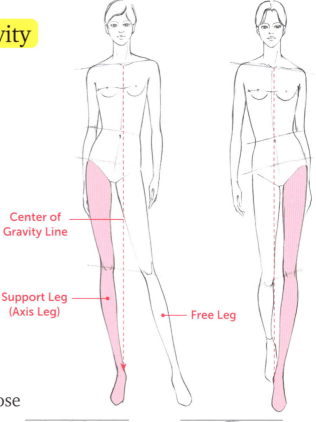

Center of Gravity Line

Support Leg (Axis Leg)

Free Leg

■ Let's Draw a One-Leg-Weighted Pose

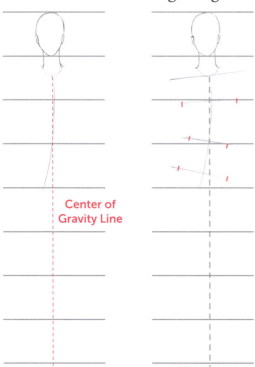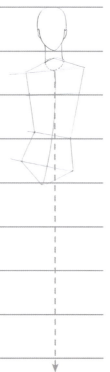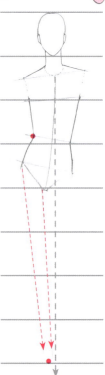

Center of Gravity Line

① Draw a vertical center of gravity line from the front neck point and sketch the body's center.

② The waistline on the side bearing the weight tilts upward. Draw guide lines for the shoulders, bust, and hips to match this tilt. Ensure that the body's width is symmetrical on both sides of the center line.

③ Connect the body's width to the shoulder line.

④ Refine the body's shape using curved lines. Draw the guide line for the support leg (axis leg).

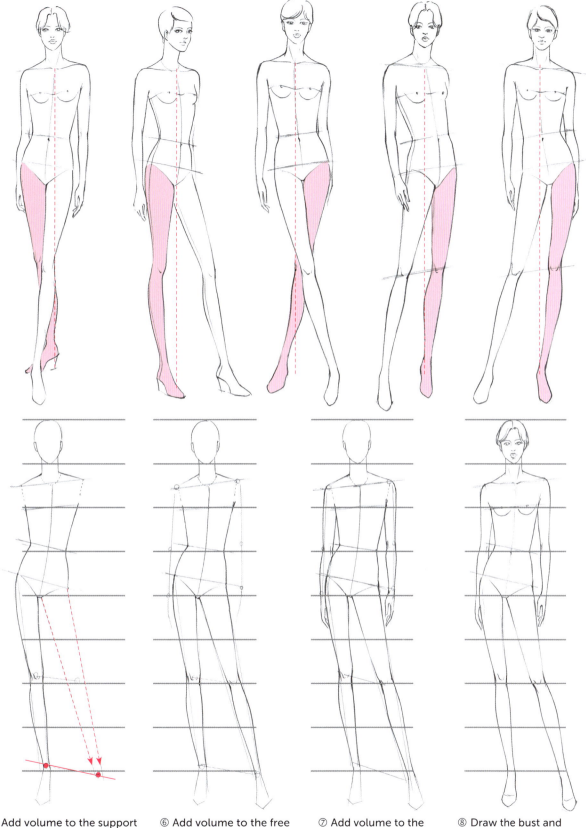

⑤ Add volume to the support leg. Draw the guide line for the free leg, positioning it diagonally to match the tilt of the hips.

⑥ Add volume to the free leg. Draw guide lines for the arms.

⑦ Add volume to the arms and hands.

⑧ Draw the bust and navel. Refine the face and feet to complete the drawing.

Facial Proportions

Let's learn the basic placement of facial features. When drawing the same person, make sure that the placement of parts, such as the height of the nose and the thickness of the lips, aligns consistently from three angles (front, side, and diagonal).

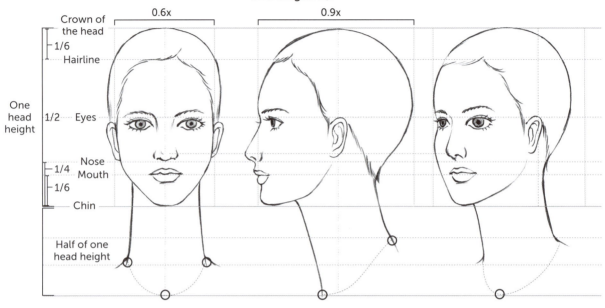

For the eyes (front view), outline them and draw the pupils. The pupil should slightly overlap with the upper eyelid.

 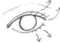 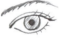

For the eyes (side view), the width is roughly half of what it is in the front view.

 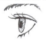

For the nose (front view), capture it three-dimensionally with the highest point at the center.

For the nose (diagonal view), narrow the width on the side farther from the center.

For the mouth (front view), determine the line where the lips meet and then add thickness to both the upper and lower lips.

For the mouth (diagonal view), narrow the width on the side farther from the center.

Eye variations

 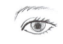
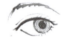 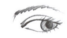

Eyebrows also follow trends. The width and angle change according to the times.

Nose

Front Side

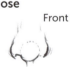 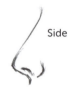

Mouth variations

The thickness of the lips can be adjusted based on personal preference.

Front View

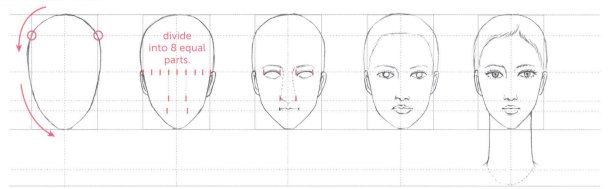

① Make the top of the head wider than the reference line.

② Divide the line at the halfway point into 8 equal parts. Mark the positions for the nose and mouth as well. Make the width of the mouth slightly wider.

③ The eyes and nose should span about two sections. The position is such that the upper eyelid overlaps the halfway line.

④ Roughly sketch in the facial features.

⑤ Draw in the details and refine the features.

Side View

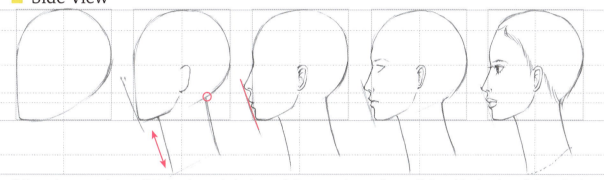

① Draw the general outline of the face without worrying about the protrusions and indentations of the facial features.

② Draw the neck. In the side view, the neck has a sharper slope. The ear is located about halfway along the width of the face.

③ Pay attention to the diagonal line formed by the nose, lips, and chin to achieve a balanced look.

④ Roughly sketch in the facial features.

⑤ Draw in the details and refine the features.

Diagonal View

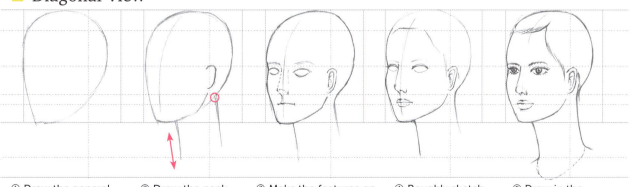

① Draw the general outline of the face without worrying about the protrusions and indentations of the facial features.

② Draw the neck. The slope will be gentler than in the side view.

③ Make the features on the far side narrower. Ensure that the philtrum of the nose and the center of the lips are aligned.

④ Roughly sketch in the facial features.

⑤ Draw in the details and refine the features.

Hairstyles

Be conscious of where the flow of the hair starts and where it is heading when drawing. Hairstyles are also important for expressing trends. Try sketching various styles that fit different eras.

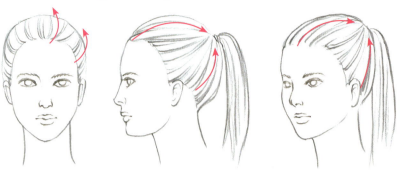

Be careful not to change the size of the head when adding volume to the hair. If you plan to add color later, keep the hair flow minimal in the initial sketch, and use the coloring process to illustrate the flow and texture of the hair.

Too far from the scalp.

Draw the hair flow without connecting the outline in one continuous line.

▪ Long Hairstyles

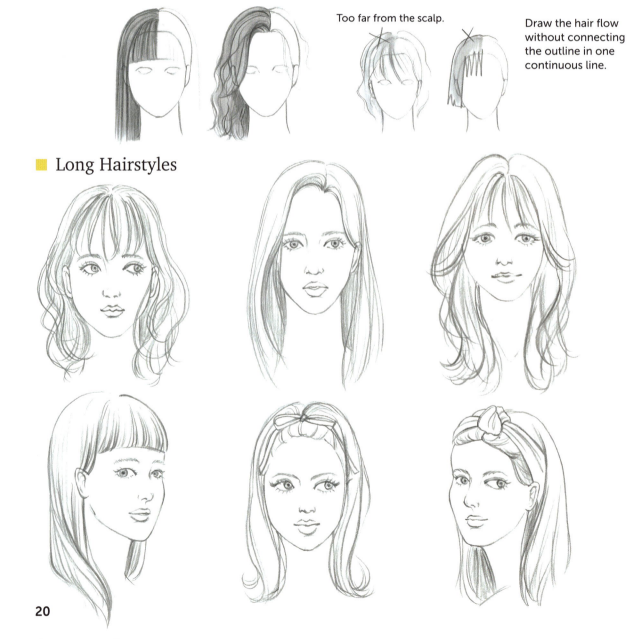

Short Hairstyles

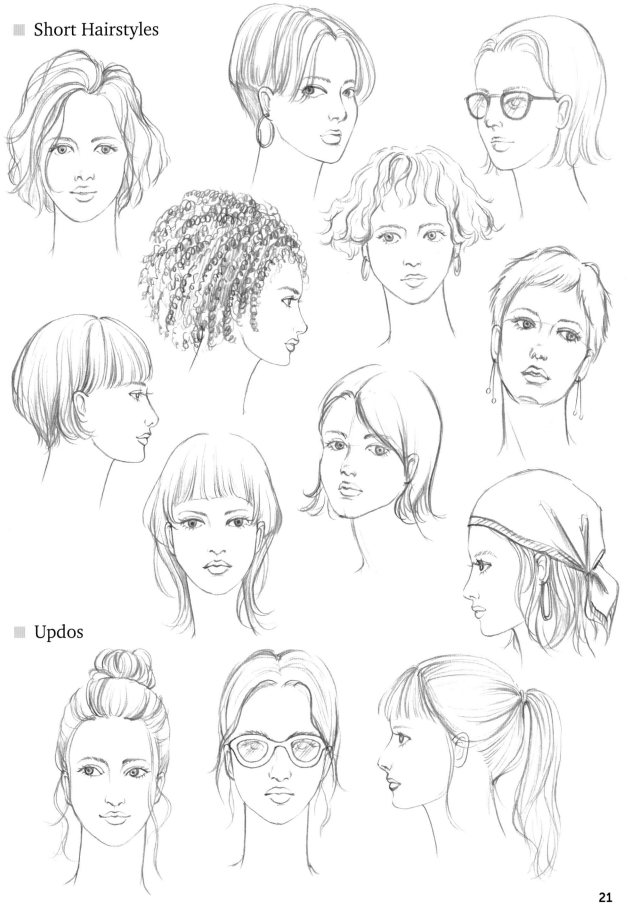

Updos

Hats

To represent hats accurately, you need to account for depth by thinking of the head as a circle. The crown should be drawn as if it wraps around the head. The brim or visor is then attached to this base. Use actual hats or photos closely when sketching these accessories.

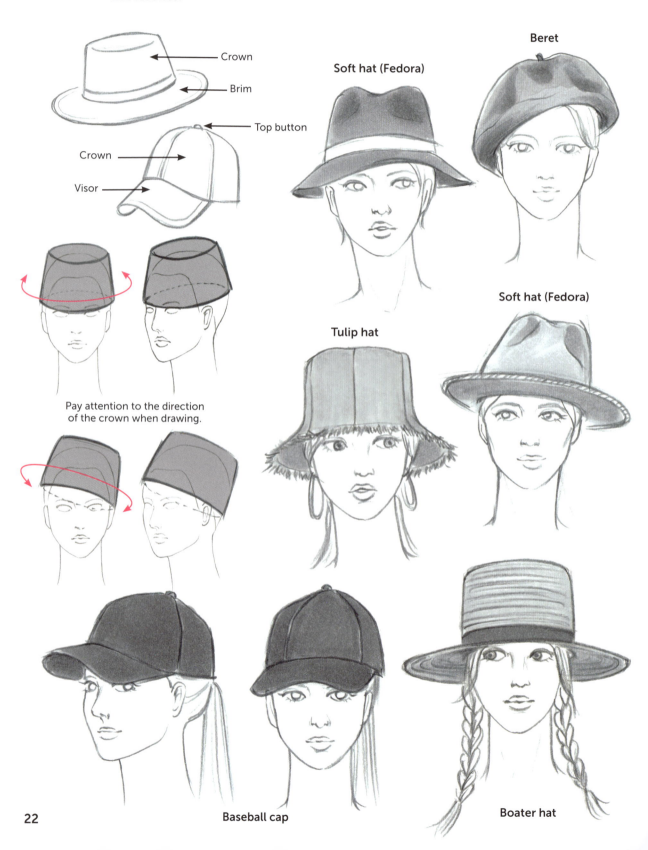

Pay attention to the direction of the crown when drawing.

Baseball cap Boater hat

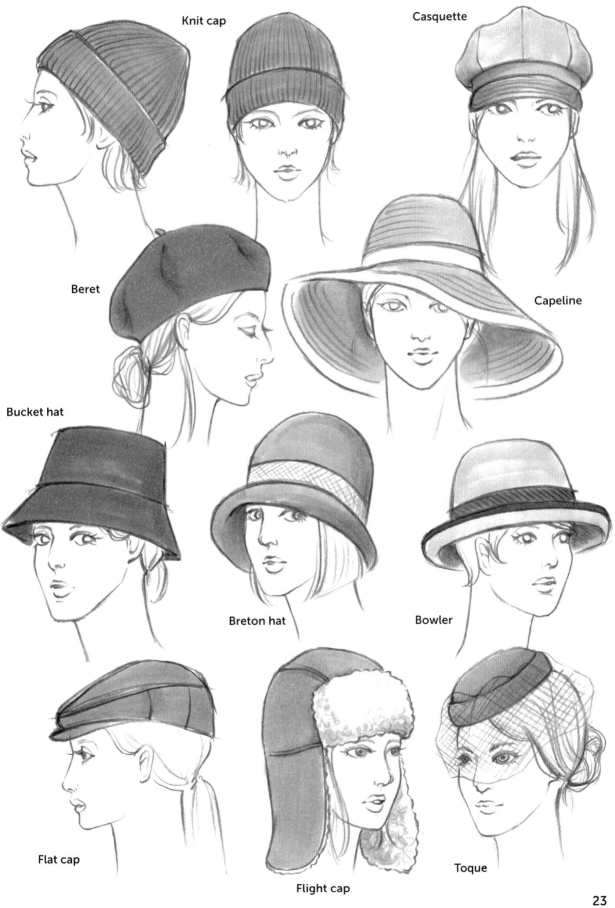

Arms and Hands

In style drawings, poses for the arms and fingertips are chosen to make the sleeve designs more visible; however, sometimes hands are used to indicate pocket designs or to grasp the hem of a skirt, serving a supportive role. Sometimes, the depiction of the fingers can be omitted. First let's capture the back of the hand and the fingers as a solid shape and draw them.

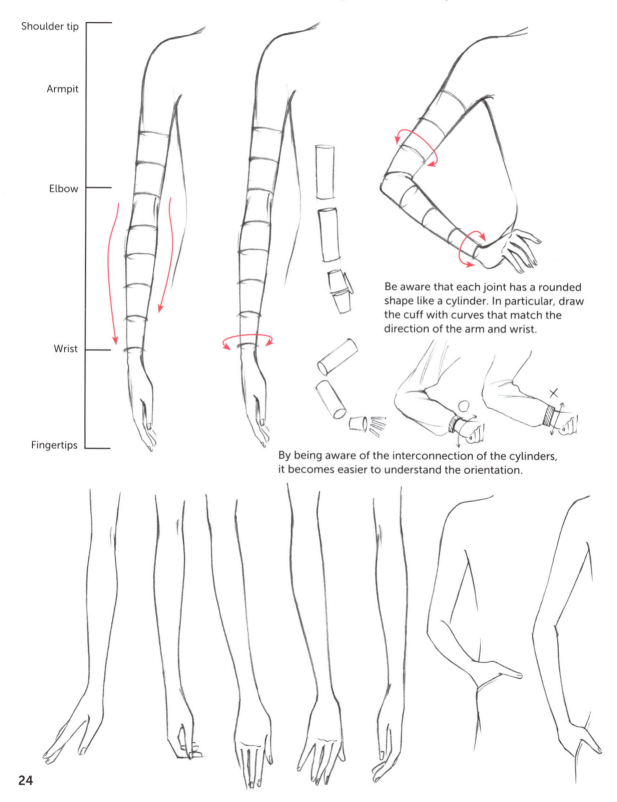

Be aware that each joint has a rounded shape like a cylinder. In particular, draw the cuff with curves that match the direction of the arm and wrist.

By being aware of the interconnection of the cylinders, it becomes easier to understand the orientation.

Since fashion illustrations often depict the human body from the front, the fingertips are often shown in a side view. The length doesn't change between the front and side views, but the width of the wrist and the thickness of the back of the hand vary significantly.

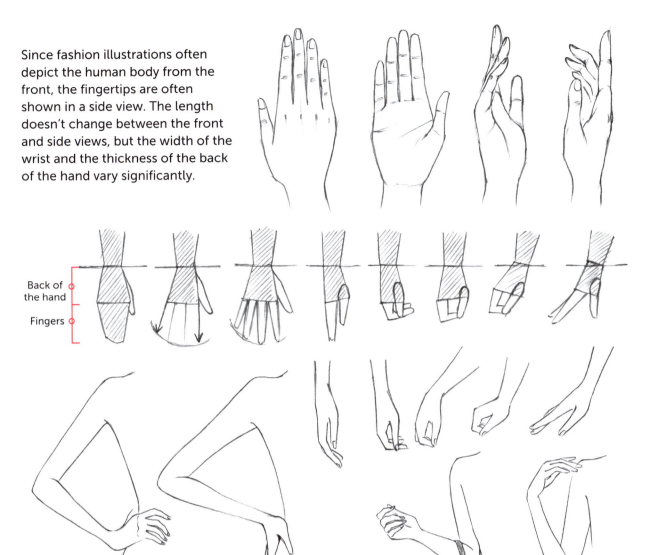

When holding bags or other items, the angle of the wrist changes based on the size and weight, and the grip style also varies.

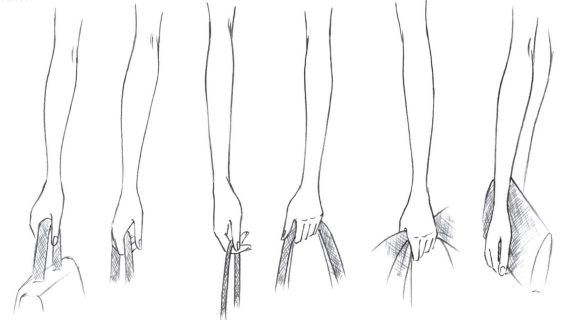

Legs and Shoes

About half of the human figure consists of the legs. It's fine to start by adding short lines, but be careful not to overlap too many unnecessary lines. Be mindful of the curves and contours created by bones and muscles, and aim to draw the lengths of each joint from the hip to the knee and the knee to the ankle in one go.

The knee and toes generally face the same direction. Be careful not to have the directions of the knee, ankle, and toes be mismatched.

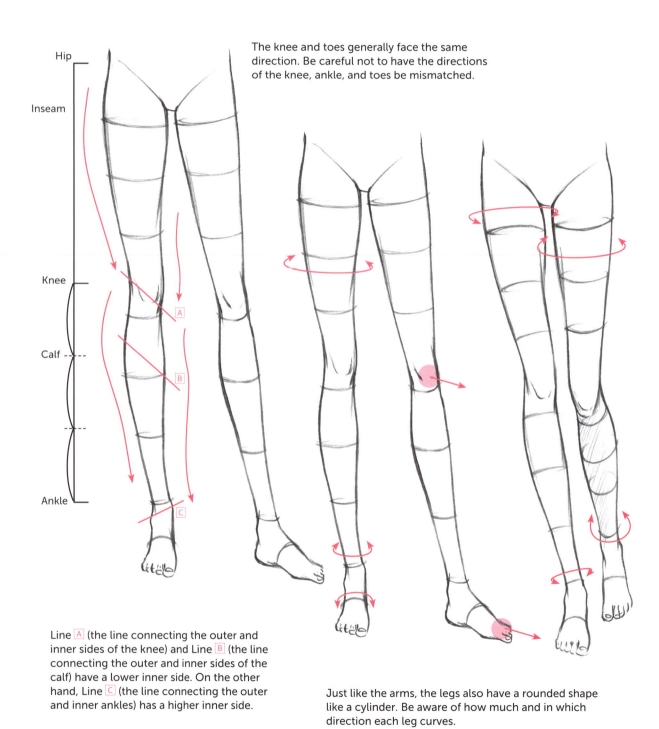

Line A (the line connecting the outer and inner sides of the knee) and Line B (the line connecting the outer and inner sides of the calf) have a lower inner side. On the other hand, Line C (the line connecting the outer and inner ankles) has a higher inner side.

Just like the arms, the legs also have a rounded shape like a cylinder. Be aware of how much and in which direction each leg curves.

Shoes are often drawn from a front or diagonal angle. Especially in the front view, since the heel isn't visible, its height is indicated by the length of the instep. Have a clear design image of the shoes you want to depict before you start drawing.

▪ How the Foot Appears

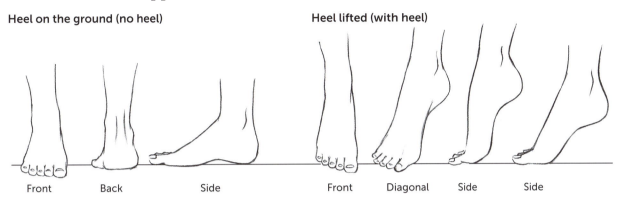

Heel on the ground (no heel): Front, Back, Side
Heel lifted (with heel): Front, Diagonal, Side, Side

▪ Heel Height and Visibility of the Instep (Front View)

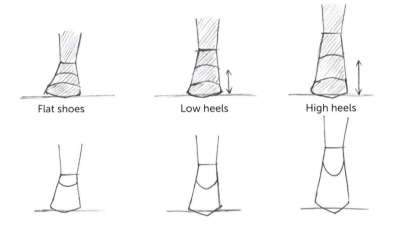

Flat shoes Low heels High heels

As the heel height increases, the visible area of the instep widens.

▪ Heel Height and Angle of the Heel (Side View)

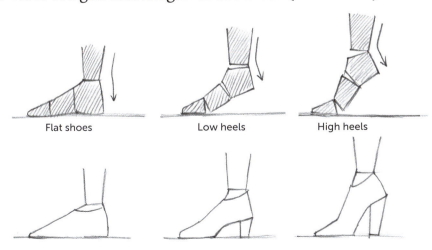

Flat shoes Low heels High heels

As the heel height increases, the leg, toes, arch, and heel move as four blocks, creating angles between each.

27

When drawing and designing footwear, first focus on the characteristics of the shoes, such as the silhouette (or overall shape), heel height, color scheme, and material. Start by sketching the silhouette loosely without focusing on details at the beginning.

■ Drawing Feet Wearing Shoes

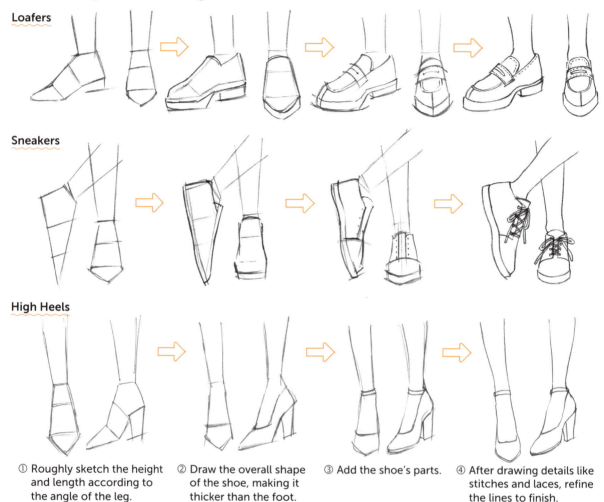

① Roughly sketch the height and length according to the angle of the leg.
② Draw the overall shape of the shoe, making it thicker than the foot.
③ Add the shoe's parts.
④ After drawing details like stitches and laces, refine the lines to finish.

■ Structure of Shoes

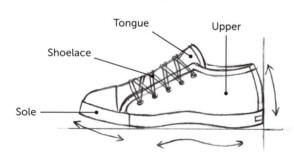

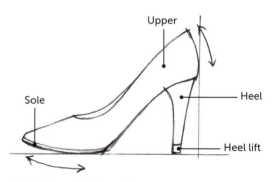

Sneakers have high cushioning, and the thickness of the sole varies. The toe is slightly raised. The eyelets for the laces are evenly placed, and the laces are threaded through the holes. For added realism, include details like stitching and the design of the sole.

The incline of the heel changes with the heel height; the higher the heel, the more slanted it becomes. The sole is slightly raised toward the toe. The bottom of the sole and heel should be aligned in height.

Shoe Styles

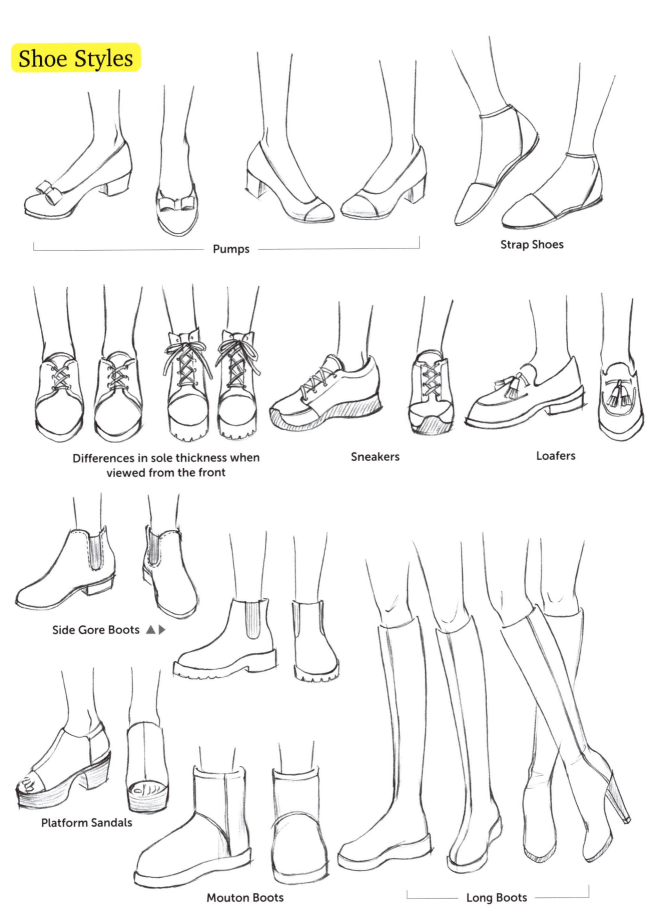

Male Proportions

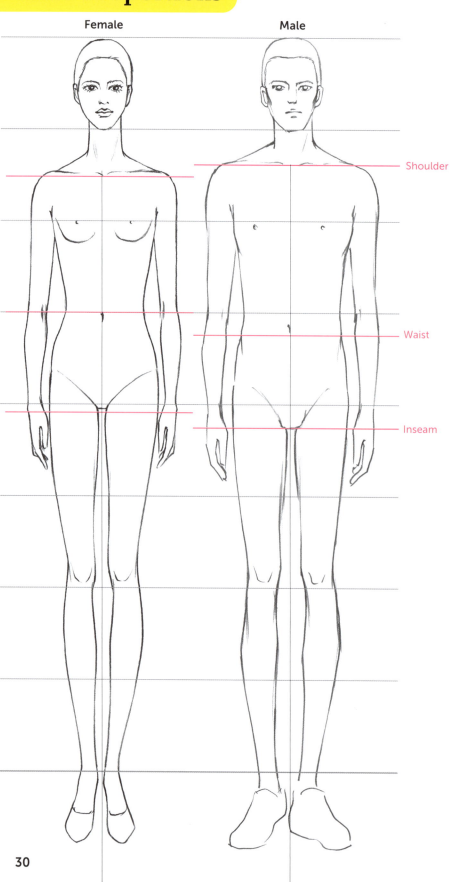

Differences from Female Proportions

- Overall more linear (women are more curvy).
- The neck is thicker.
- The neckline and shoulder points are positioned higher.
- Less difference between chest, waist, and hips.
- The waist is positioned lower.
- The inseam position is lower.
- The joints are thicker.

The addition of muscles determines whether the body appears more robust or slender. When depicting an active image like sportswear, it's good to exaggerate the body slightly.

Basic Facial Balance

Key Points for Drawing

- Don't make the chin too sharp.
- Position the facial features slightly higher than on a woman's face.
- Use overall straight lines.
- Make the hairline more squared (women's hairlines are more rounded).

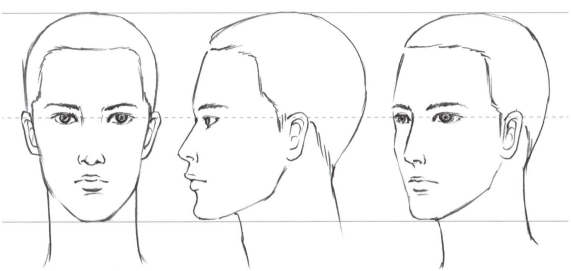

Hairstyle Variations

Hairstyles change with the trends of the times.
Short styles, shaggy bad-boy looks, with bangs or without: Coordinate hairstyles to match the clothing.

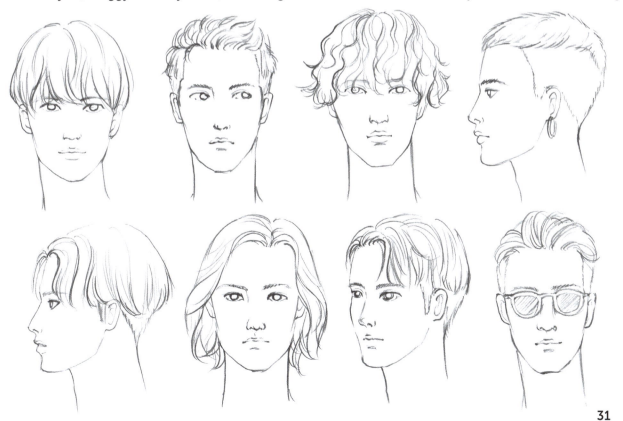

Pose Variations

Men's poses tend to use smaller movements compared to women's. Poses like placing hands in jacket or pants pockets are often used, as they make it easier to showcase the clothing design.

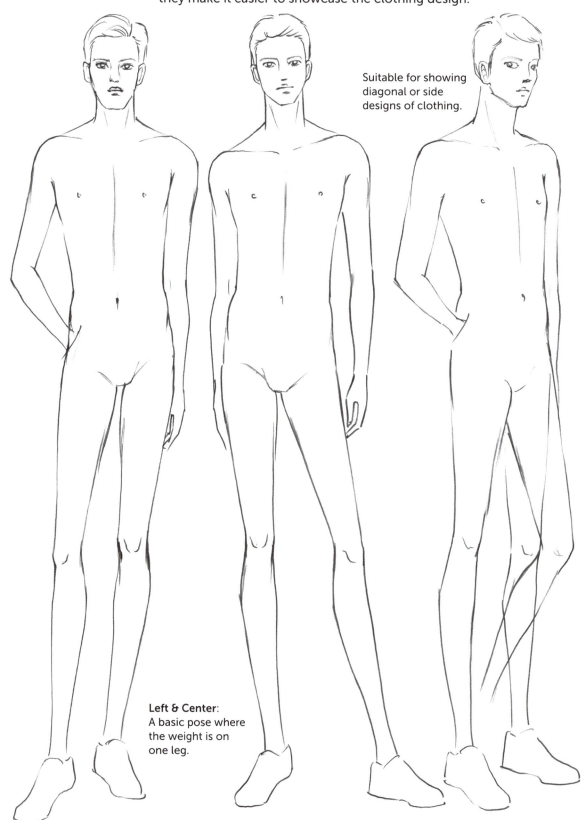

Suitable for showing diagonal or side designs of clothing.

Left & Center: A basic pose where the weight is on one leg.

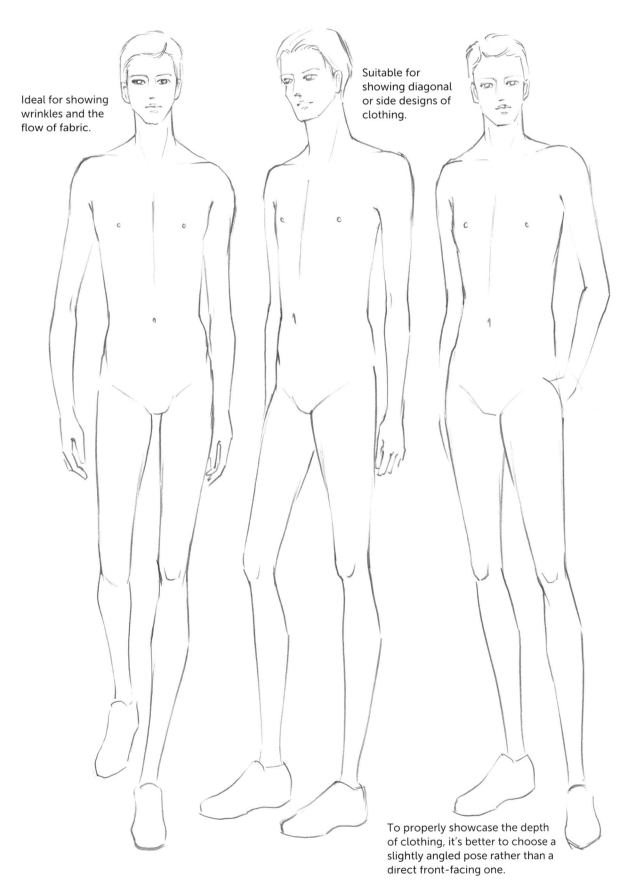

Ideal for showing wrinkles and the flow of fabric.

Suitable for showing diagonal or side designs of clothing.

To properly showcase the depth of clothing, it's better to choose a slightly angled pose rather than a direct front-facing one.

Designing for Men

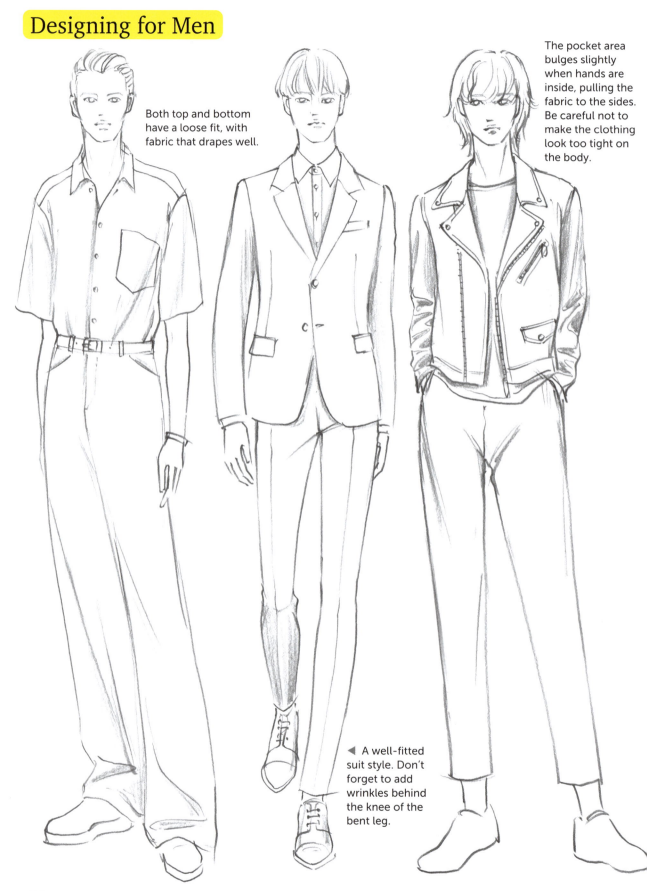

Both top and bottom have a loose fit, with fabric that drapes well.

The pocket area bulges slightly when hands are inside, pulling the fabric to the sides. Be careful not to make the clothing look too tight on the body.

◀ A well-fitted suit style. Don't forget to add wrinkles behind the knee of the bent leg.

2 Drawing Fabrics and Garments

Fabric in Motion: Wrinkles

When drawing wrinkles, there are two main reasons they occur:

A. When movement is applied while wearing clothes:
- There is movement in the body, such as when weight is placed on one side, when walking, or when bending the arms or knees.
- The fabric shrinks due to movement, such as when the sleeves are rolled up.

B. When wrinkles are incorporated into the clothing design:
- Gathering fabric is used.
- Drapes are intentionally added to the design.
- Fabric falls downward from stitching points or fasteners.

If a piece of fabric is supported at one point, the rest of the fabric naturally falls downward. When supported at two points, the appearance of the wrinkles changes depending on the position of those points.

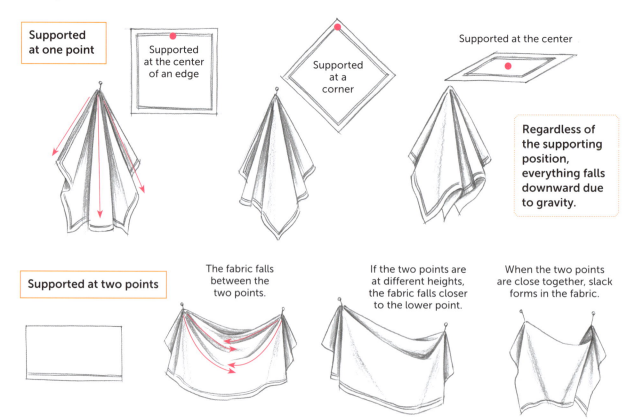

■ Wrinkles Caused by Applied Force

When fabric sewn into a tube shape is scrunched, it creates wrinkles commonly seen in sleeves or the hems of pants. These wrinkles are characterized by alternating lines from both sides.

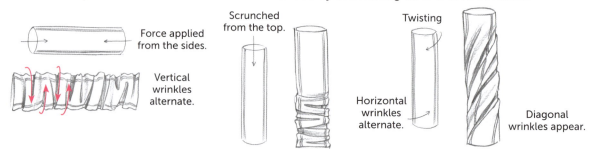

Wrinkles Created by Movement

These types of wrinkles are especially common around joints, such as elbows, hips, and knees. They form when fabric gets caught or is pulled.

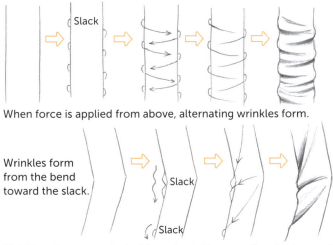

When force is applied from above, alternating wrinkles form.

Wrinkles form from the bend toward the slack.

Wrinkles change on the inside and outside, as well as the top and bottom, of the bent part of the garment.

How wrinkles form when bending

Let's Look at Wrinkles in Clothes

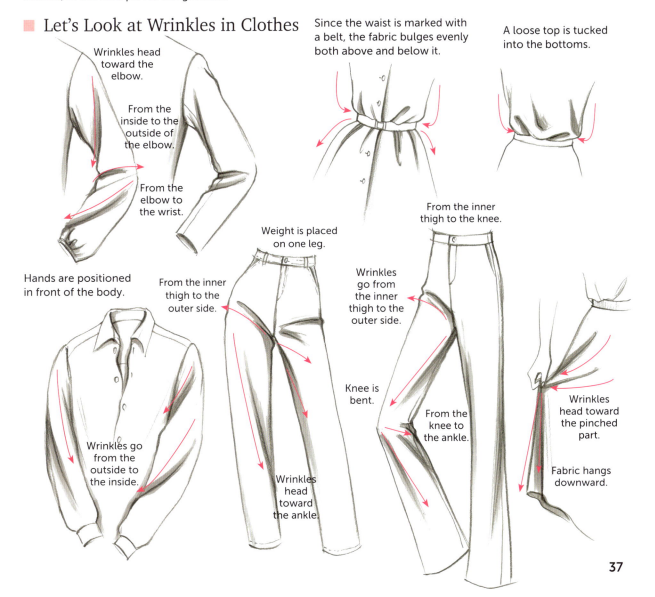

Wrinkles head toward the elbow.

From the inside to the outside of the elbow.

From the elbow to the wrist.

Hands are positioned in front of the body.

Wrinkles go from the outside to the inside.

Since the waist is marked with a belt, the fabric bulges evenly both above and below it.

A loose top is tucked into the bottoms.

Weight is placed on one leg.

From the inner thigh to the outer side.

Wrinkles head toward the ankle.

Knee is bent.

From the inner thigh to the knee.

Wrinkles go from the inner thigh to the outer side.

From the knee to the ankle.

Wrinkles head toward the pinched part.

Fabric hangs downward.

37

Sketching Wrinkles and Folds

Let's start to grapple with the characteristics and movement of fabric. When drawing by hand, you'll notice qualities and details previously overlooked, like how lines connect and how shadows fall.

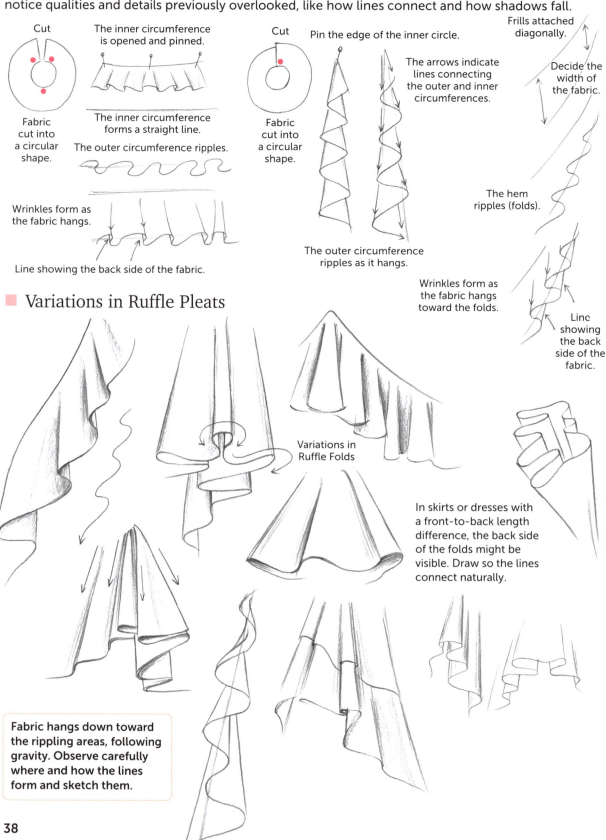

Cut — Fabric cut into a circular shape.
The inner circumference is opened and pinned.
The inner circumference forms a straight line.
The outer circumference ripples.
Wrinkles form as the fabric hangs.
Line showing the back side of the fabric.

Cut — Fabric cut into a circular shape.
Pin the edge of the inner circle.
The arrows indicate lines connecting the outer and inner circumferences.
The outer circumference ripples as it hangs.
Wrinkles form as the fabric hangs toward the folds.

Frills attached diagonally.
Decide the width of the fabric.
The hem ripples (folds).
Line showing the back side of the fabric.

■ **Variations in Ruffle Pleats**

Variations in Ruffle Folds

In skirts or dresses with a front-to-back length difference, the back side of the folds might be visible. Draw so the lines connect naturally.

Fabric hangs down toward the rippling areas, following gravity. Observe carefully where and how the lines form and sketch them.

38

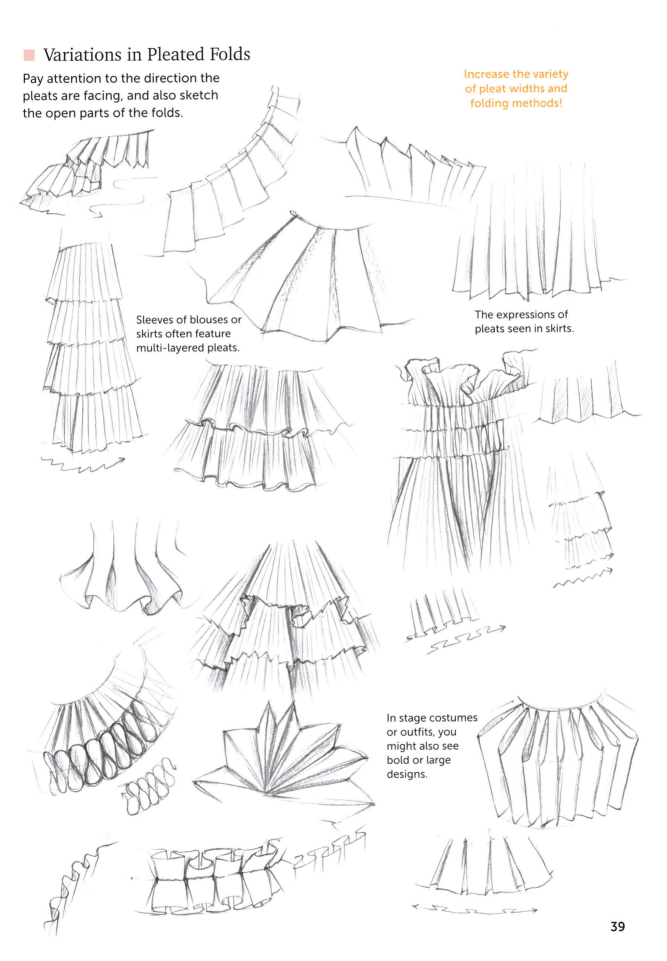

Sketching Gathers

Gathers are created when fabric is sewn and the thread is pulled to create folds.

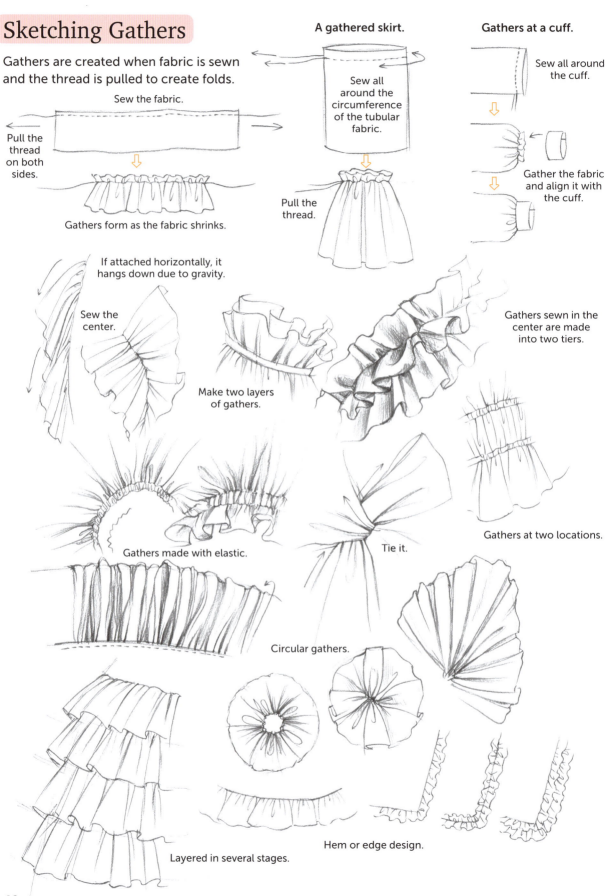

Draping

Folds that hang loosely are called drapes. They are often features in gowns and formal wear.

When drawing drapes, carefully observe where the fabric starts and where it connects. Also, since overlaps occur, add shadows to create a sense of depth.

Thin, flowing fabric like georgette.

Be careful not to lose track of the flow.

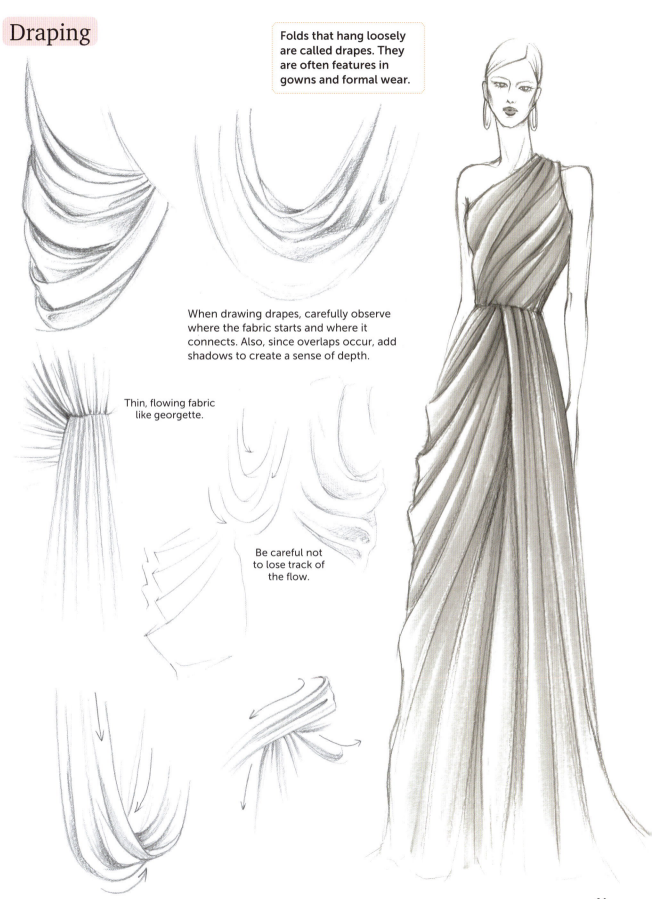

Differences in Materials

When drawing fabric, you need to consider the material. Try to remember the feel and look of it, by touching and holding it. It's also good to take notes on the qualities of certain common fabrics and materials.

Organza

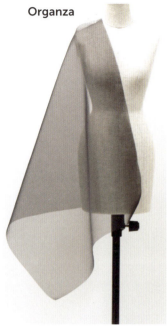

It's thin and very transparent. It has a strong tension. The characteristic feature is the taut lines that stretch out sharply.

Chiffon

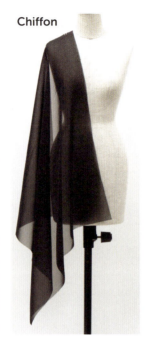

It is thin with a stiff texture. Compared to organza, it has more weight and a flowing quality.

Satin

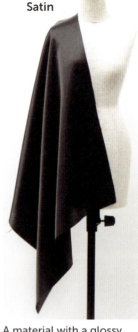

A material with a glossy surface that particularly lends itself to gathers.

Velvet

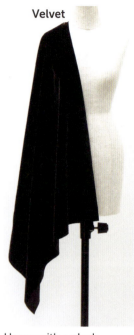

Heavy with a plush texture and smooth surface, it hangs straight down like chiffon.

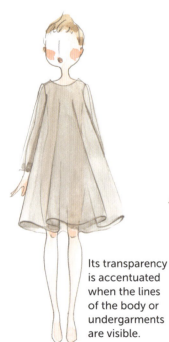

Its transparency is accentuated when the lines of the body or undergarments are visible.

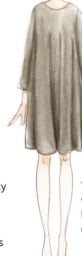

There's little volume, and the lines of the folds drop downward.

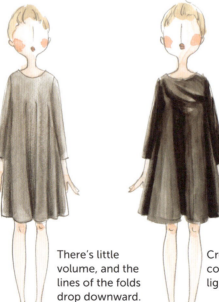

Creates a clear contrast between light and shadow.

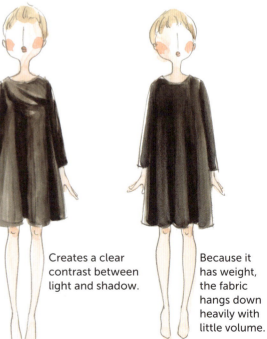

Because it has weight, the fabric hangs down heavily with little volume.

42

Cotton broadcloth (thick)	Wool satin (thin)	Wool flannel (thick)
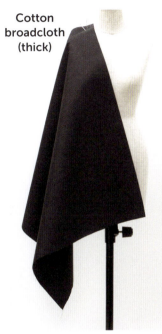	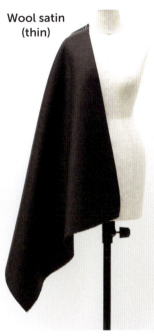	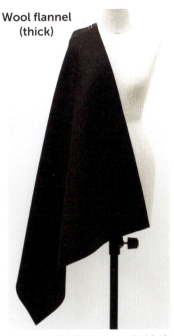
It's slightly thicker than T-shirt fabric. It has strong tension and wrinkles easily.	Commonly seen in suit fabrics, it has a smooth texture. Heavier than cotton.	It has a solid thickness suitable for coats. The tension and thickness create an exaggerated silhouette when you gather the folds.
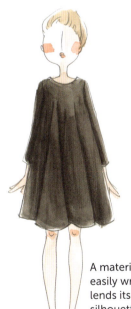	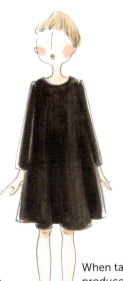	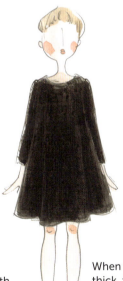
A material that easily wrinkles, it lends itself to large silhouettes.	When tailored, it produces a smooth and crisp line. Adding a little light enhances the fabric.	When the fabric is thick, fine pleats don't form. It creates larger and more billowy curves when compared to thin fabric.

Looking at Lines

A single piece of clothing incorporates many layers and folds of fabric. By differentiating the lines, you can convey more visual information to others, making the garment more distinct and defined.

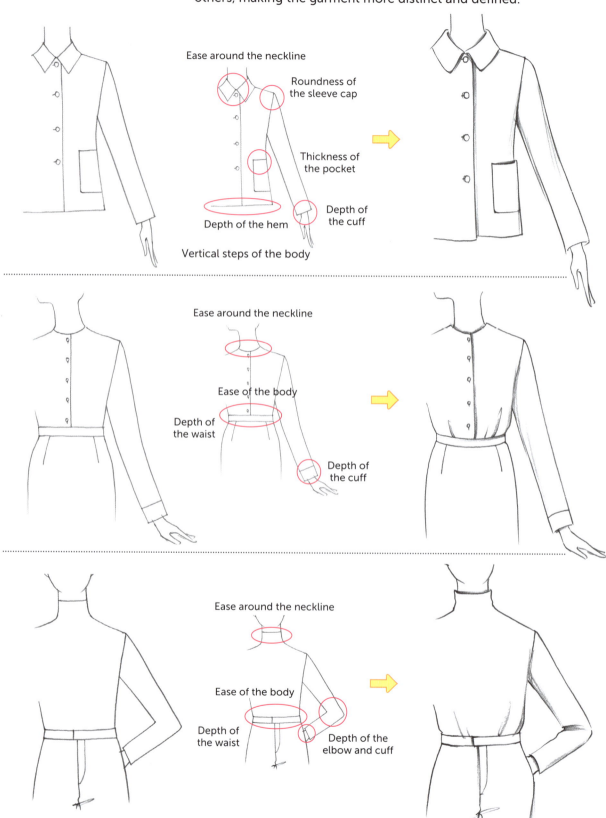

Thin Fabric

Jacket: For a fabric with tension, the corners of the collar and the wrinkles at the waist are represented with straight, crisp lines.
Skirt: It depicts a thin, gooey-looking fabric. The way it hangs down is characteristic.

Thick Fabric

Jacket: To create a fluffy impression, the corners are rounded.
Skirt: The flare and folds have larger waves.

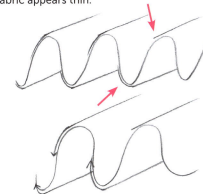

If all the lines are connected, the fabric appears thin.

Draw lines with slight differentiation to create a sense of thickness.

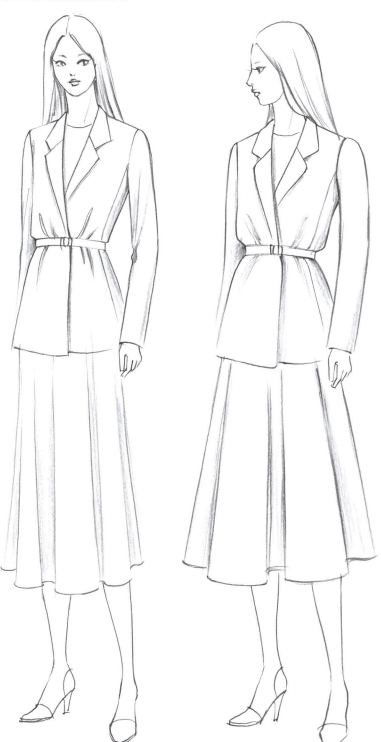

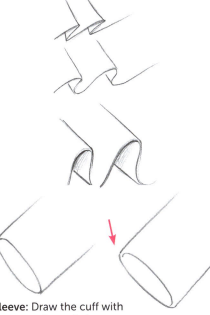

Sleeve: Draw the cuff with a slight differentiation.

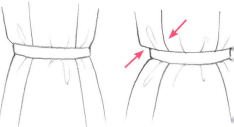

Waist area: Make the difference from the belt larger and be aware of the lines that cinch inward.

45

Fabrics and the Body

The human body has curves, contours and bulges, creating a three-dimensional structure. However, in drawings, we indicate three-dimensionality by utilizing lines and shadows. Clothing can be made simply by creating holes for the neck, arms, and legs to fit, covering the entire body.

To fit flat fabric to the body, adjustments are made by folding or tacking. Darts and seams are primarily used for this.

Darts: A technique used to shape fabric into three dimensions. It involves tacking a portion of the fabric and sewing it (see pages 47–49).

Seams: Lines (stitching) created when sewing pieces of fabric together. They're used to shape the fabric into three dimensions like darts or are incorporated as design elements (see pages 47–48).

Tucks: The effects created by folding the fabric. They're often added at the waist to provide dimension and ease. There are two ways to fold: one-sided and matched (see pages 48–49).

■ Dress Form

It is important to view the body's contours from various angles.

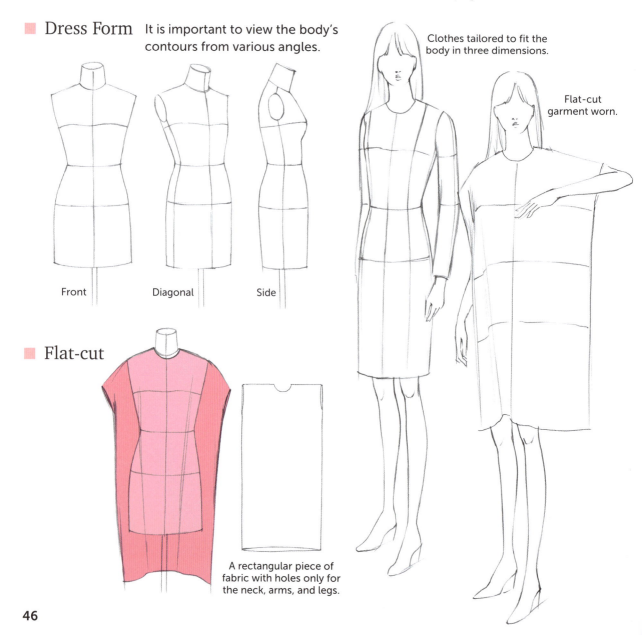

Front Diagonal Side

Clothes tailored to fit the body in three dimensions.

Flat-cut garment worn.

■ Flat-cut

A rectangular piece of fabric with holes only for the neck, arms, and legs.

All About Darts

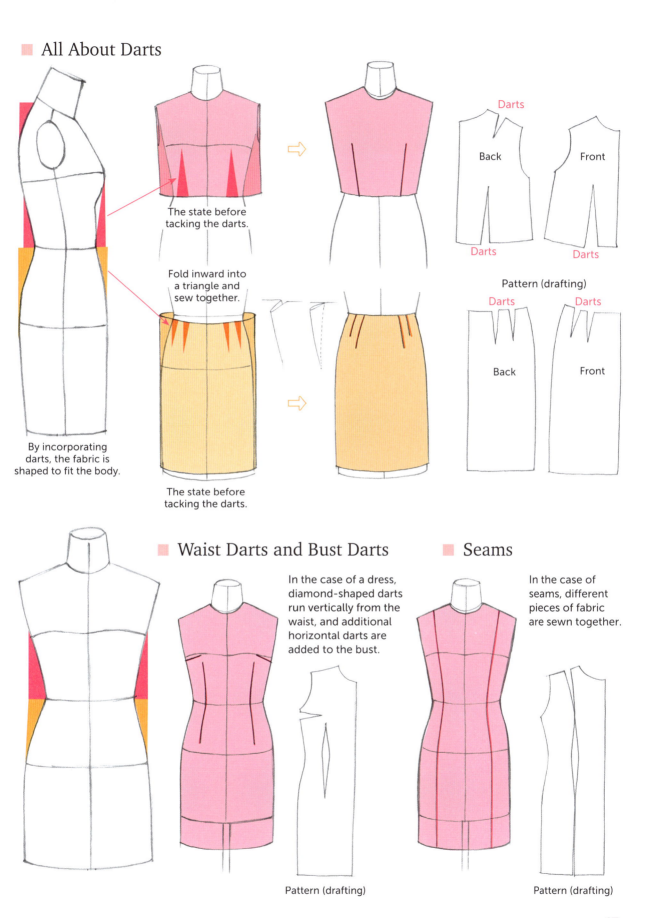

By incorporating darts, the fabric is shaped to fit the body.

The state before tacking the darts.

Fold inward into a triangle and sew together.

The state before tacking the darts.

Pattern (drafting)

Waist Darts and Bust Darts

In the case of a dress, diamond-shaped darts run vertically from the waist, and additional horizontal darts are added to the bust.

Pattern (drafting)

Seams

In the case of seams, different pieces of fabric are sewn together.

Pattern (drafting)

47

The positions of darts, seams, tucks, and gathers are decided according to the overall design and characteristics of the fabric, including areas beyond the basic form.

■ Darts

■ Seams

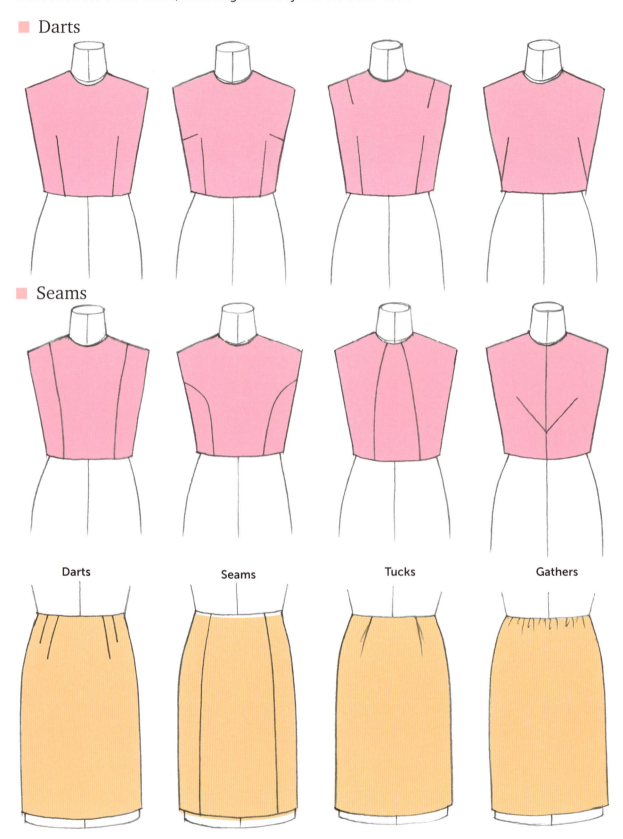

Darts Seams Tucks Gathers

Darts and tucks may appear as a single line in the drawing, but their specifications and design intentions are entirely different. If the depiction is ambiguous, it may not be effectively conveyed. The way lines are drawn and how shadows are applied distinguish each specification.

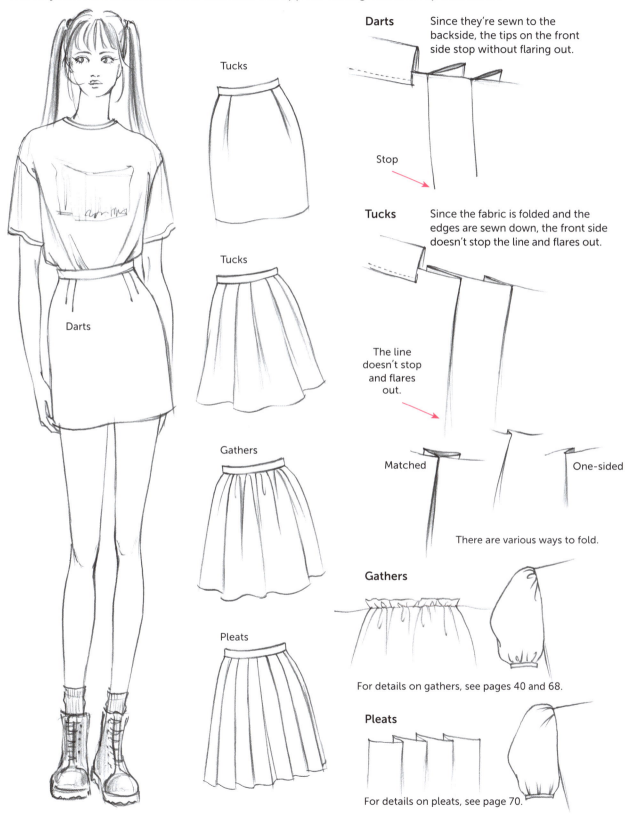

Darts — Since they're sewn to the backside, the tips on the front side stop without flaring out.

Stop

Tucks — Since the fabric is folded and the edges are sewn down, the front side doesn't stop the line and flares out.

The line doesn't stop and flares out.

Matched / One-sided

There are various ways to fold.

Gathers

For details on gathers, see pages 40 and 68.

Pleats

For details on pleats, see page 70.

49

Details

Details don't pertain to the overall silhouette or pattern of clothing but rather to the design elements such as collars, sleeves, buttons, pockets, and craft-like features. Among these, the types of necklines, collars, and sleeves play a significant role in determining the overall look, style and impact of the garment.

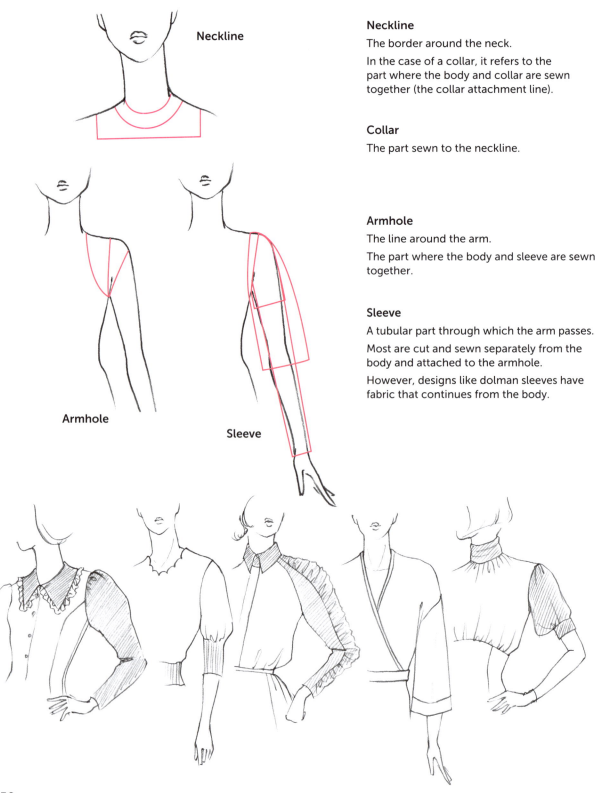

Neckline
The border around the neck.
In the case of a collar, it refers to the part where the body and collar are sewn together (the collar attachment line).

Collar
The part sewn to the neckline.

Armhole
The line around the arm.
The part where the body and sleeve are sewn together.

Sleeve
A tubular part through which the arm passes.
Most are cut and sewn separately from the body and attached to the armhole.
However, designs like dolman sleeves have fabric that continues from the body.

Necklines

Basic designs of necklines include:

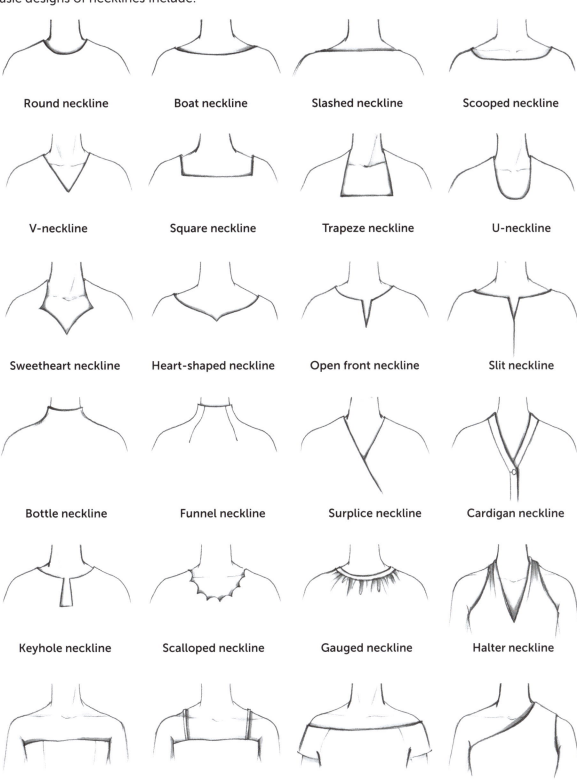

Collars

Basic designs of collars include:

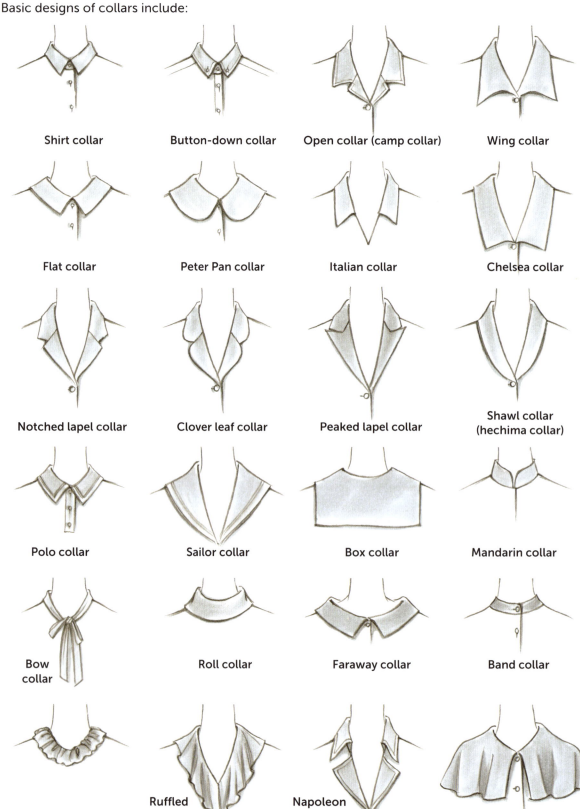

Sleeves

Basic designs of sleeves include:

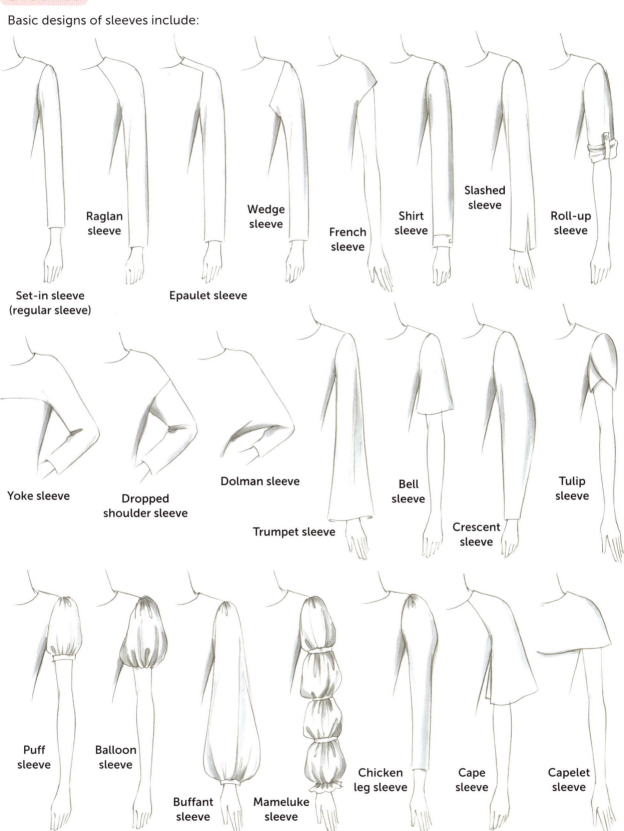

Other Details

There are various types of details that are necessary for practicality, as well as decorative details.

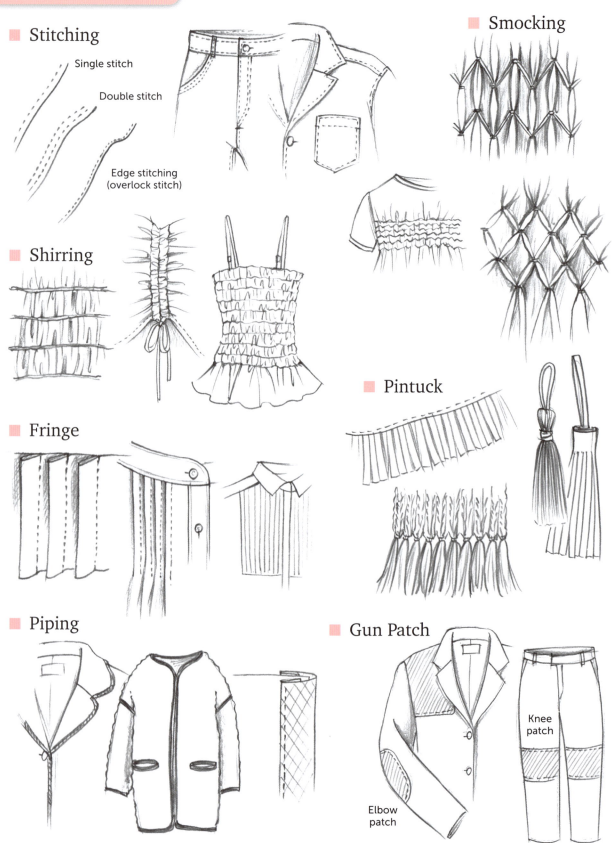

- Stitching
 - Single stitch
 - Double stitch
 - Edge stitching (overlock stitch)
- Smocking
- Shirring
- Pintuck
- Fringe
- Piping
- Gun Patch
 - Elbow patch
 - Knee patch

Ribbons and Knots

When creating knots with ribbons, cords, or scarves, first check the width and size of the item.
 Next, consider the texture of the material (stiff and hard, thin and fuzzy, thick and soft). For heavier materials, it's necessary to depict them as drooping downward. Pay attention to the texture of each material as you draw.

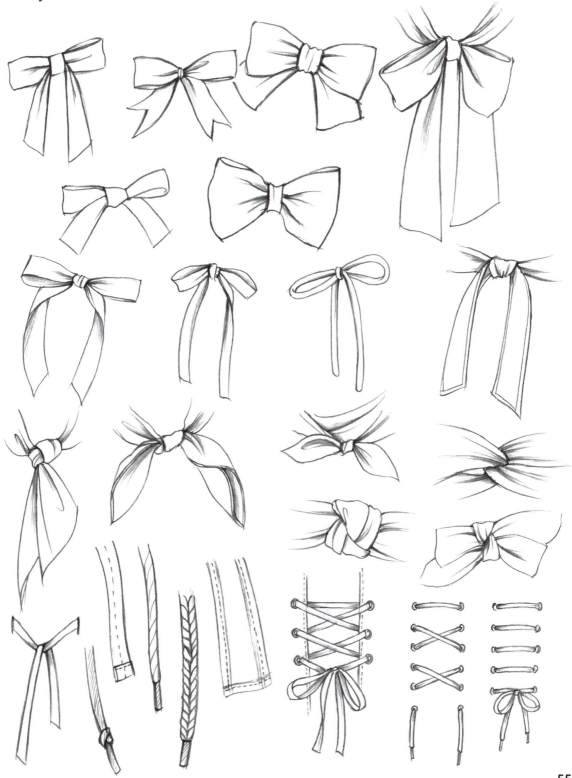

Fasteners and Accessories

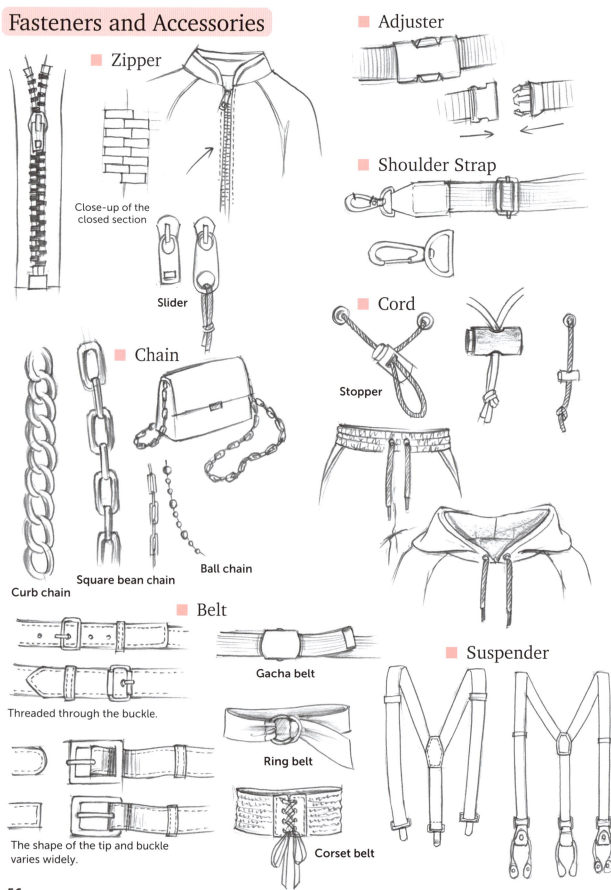

Bags and Gloves

Pay attention not only to the shape of the main body but also to the number and length of the handles and the presence or absence of gussets.

When coordinating a bag in a sketch, the angle and position held in the hand are key considerations.

■ Construction and Types of Bags

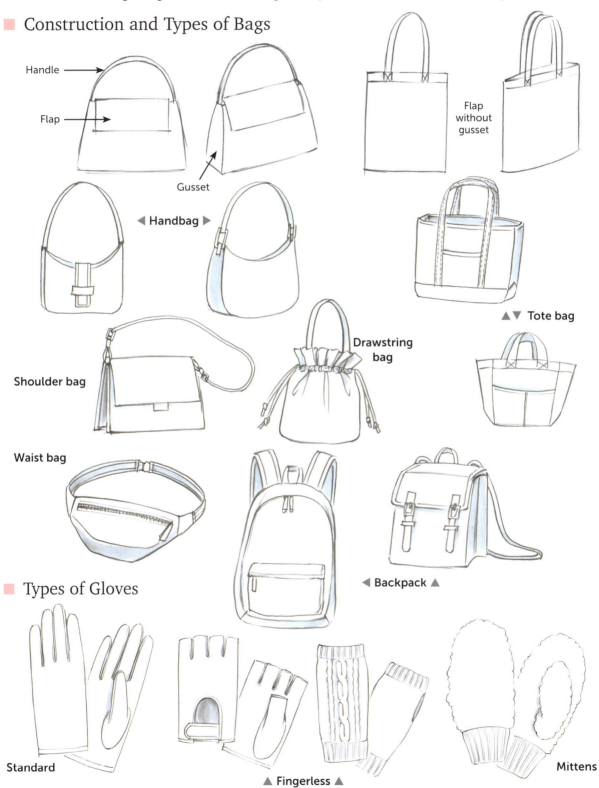

■ Types of Gloves

Pockets

Patch Pockets
Design Variations

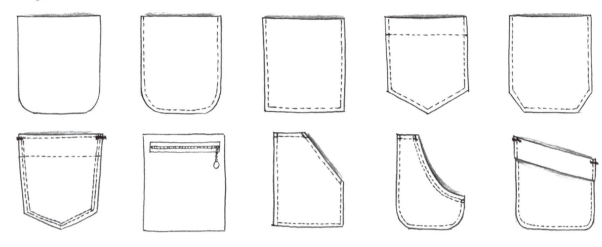

Patch Pocket with Flap
Design Variations

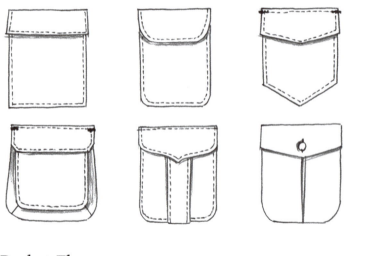

Pocket Flaps
Design Variations

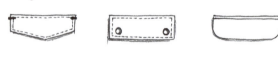

Rimmed Pocket

A pocket with the cut edge treated with a separate fabric.

Boxed Pocket

A cut pocket with a box-shaped mouth fabric attached.

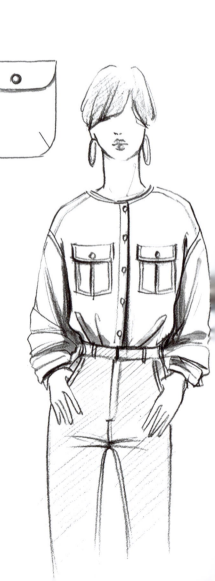

58

3 Illustrating and Designing Clothes

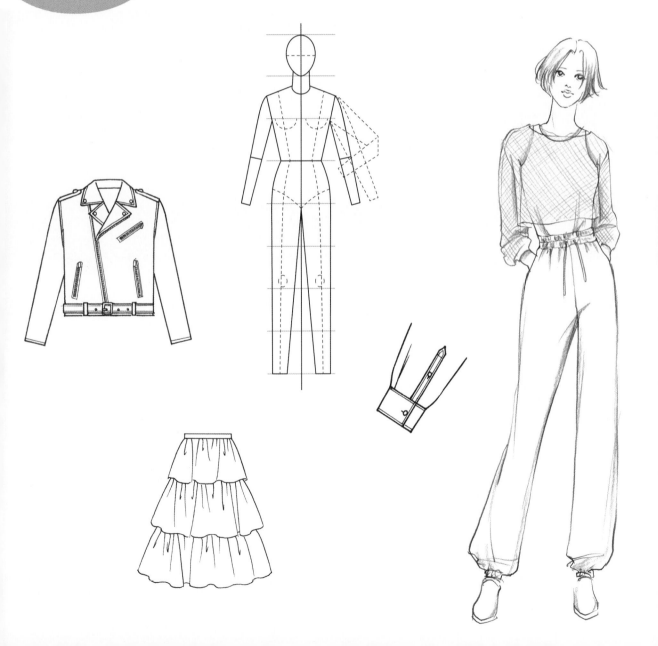

Drawing Individual Items

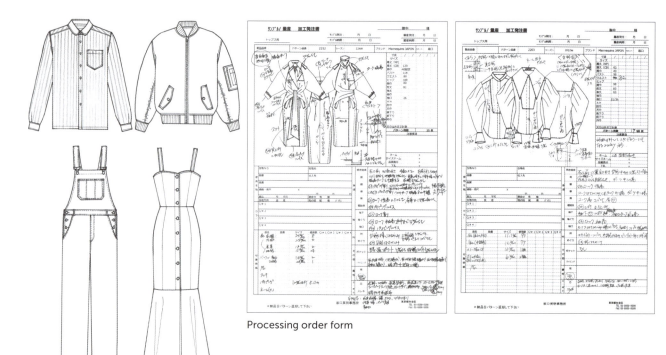

Processing order form

Drawings of individual pieces, garments and accessories are used in the production process, often including sewing specifications and processing orders, and are also used for catalogs, product lists, and promotional items. These drawings play an important role in relaying information not only to designers, but also to pattern makers, textile factories, and production managers in an apparel company. So those illustrations naturally contain more details and information than informal drawings and sketches.

Let's review some points to keep in mind when drawing individual items and pieces:
◆ Don't layer items. Draw each one individually.
◆ Generate the front and back designs together.
◆ Don't draw wrinkles that are created when the item is worn. Draw wrinkles (gathers, drapes, etc.) clearly as required by the design.
◆ Create symmetrical designs (asymmetrical designs should be drawn as such).
◆ Keep the body balanced (no shapes or arm lengths that vary from one drawing to the next).
◆ Show straight and curved lines accurately (get used to drawing with a ruler).
◆ Use a fine-tipped pen or similar tool for finishing (pencil lines may disappear or the thickness of the lines may not be uniform).

More and more often, we draw using a computer, but even if the lines are clean by using computer software, digital design tools don't answer all your needs if the necessary points are not captured. First, practice drawing silhouettes, capturing volume, and necessary details by hand. Clean lines using a pen are also difficult and time-consuming at first. With repeated practice, you'll be able to smoothly draw straight and curved lines with a ruler.

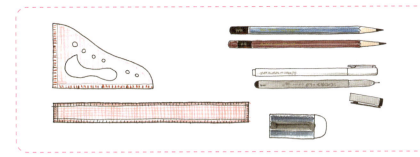

What You'll Need
- straight ruler
- curved ruler
- pencil & mechanical pencil
- fine-tipped pen
- eraser
- thin/tracing paper
- body outline (pages 62–63)

The body balance should be the same even after many drawings, so use an outline or silhouette with the same ratio (included on pages 62–63).

For reference, one head of the body = approximately 8 inches (20.3 cm) in actual size, which yields an illustration close to the actual size of the body. For example, the length of the pleated skirt below is approximately 27.5 inches (70 cm), which is half the length of three heads.

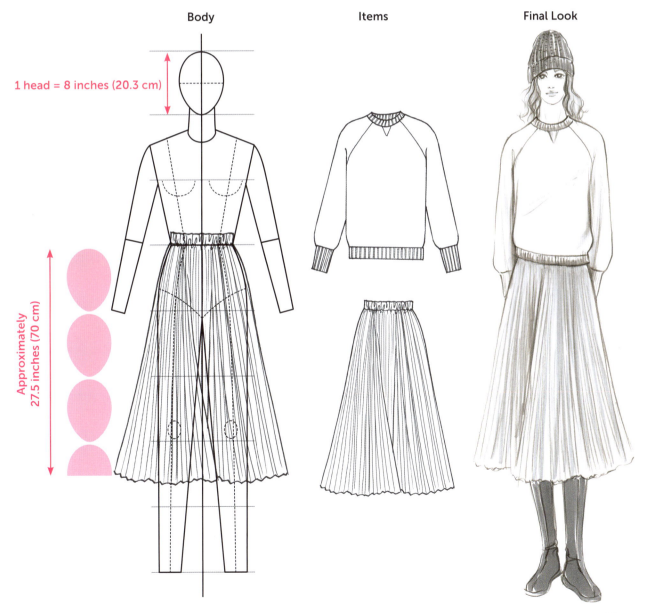

61

Female Bodies

Front

Back

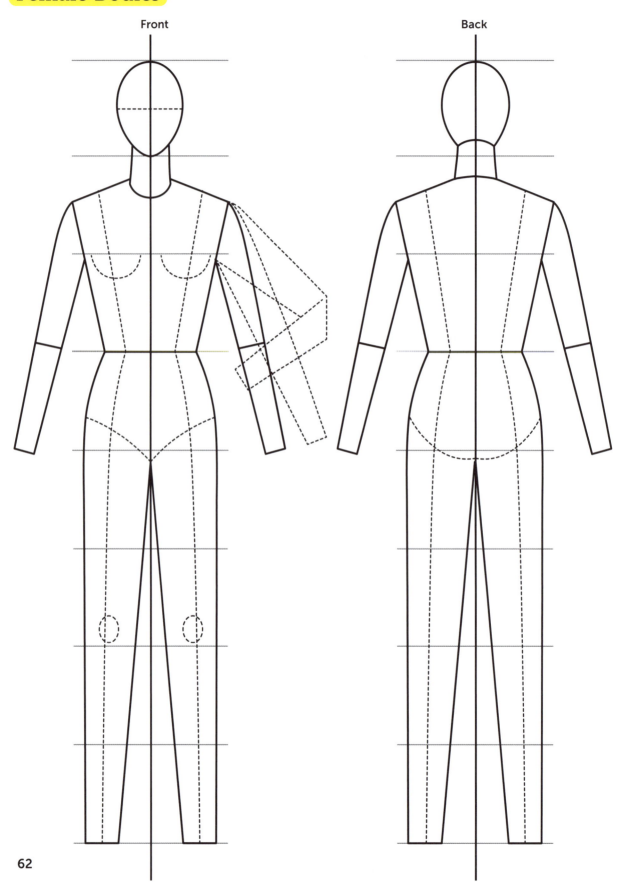

Male Bodies

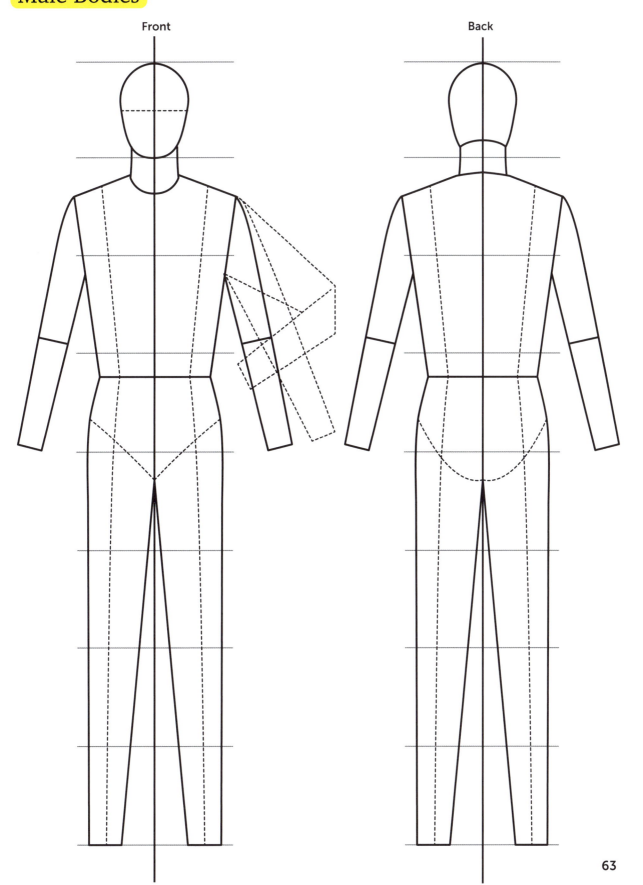

Skirts

Tight Skirts

This style of skirt has a straight silhouette from the hips to the hem. Non-stretch fabrics require an opening that suits the design, such as front opening, back opening, side opening, and elastic-based.

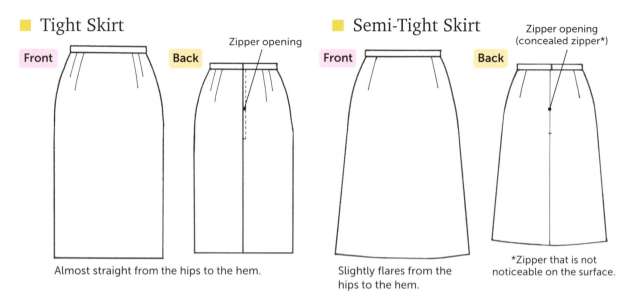

Tight Skirt
Almost straight from the hips to the hem.

Semi-Tight Skirt
Slightly flares from the hips to the hem.

*Zipper that is not noticeable on the surface.

Waist Position and Length

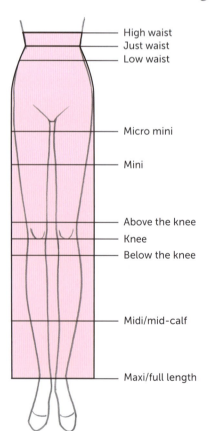

- High waist
- Just waist
- Low waist
- Micro mini
- Mini
- Above the knee
- Knee
- Below the knee
- Midi/mid-calf
- Maxi/full length

Types of Openings

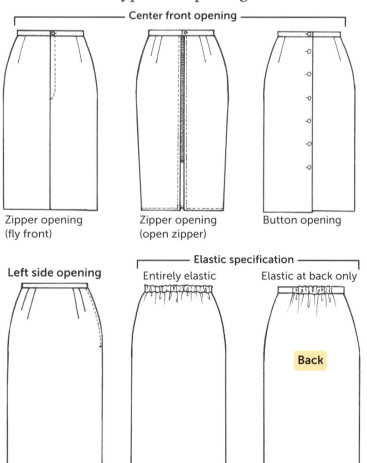

Center front opening
- Zipper opening (fly front)
- Zipper opening (open zipper)
- Button opening

Left side opening

Elastic specification
- Entirely elastic
- Elastic at back only

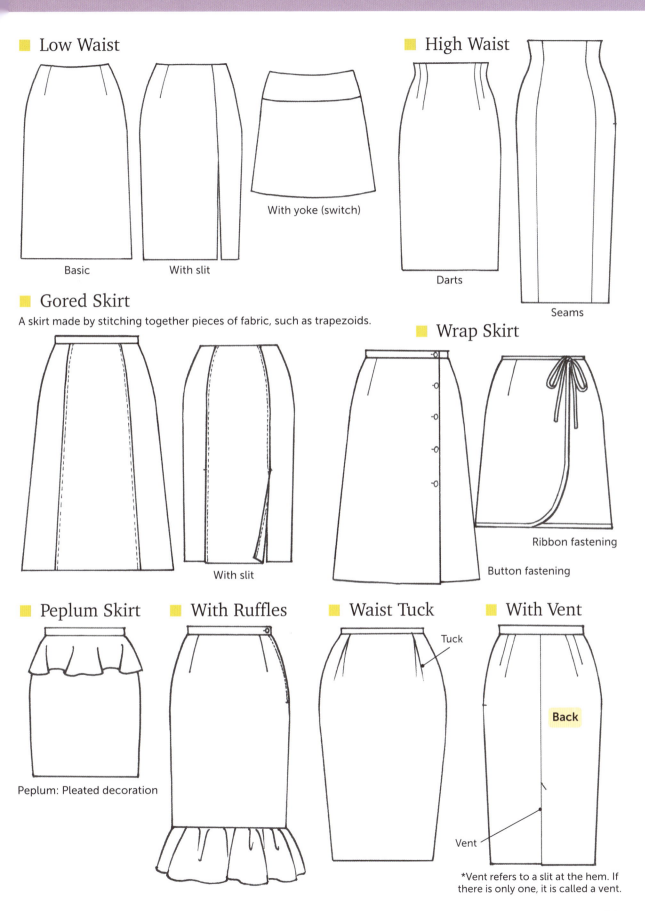

Low Waist
Basic — With slit — With yoke (switch)

High Waist
Darts — Seams

Gored Skirt
A skirt made by stitching together pieces of fabric, such as trapezoids.

With slit

Wrap Skirt
Button fastening — Ribbon fastening

Peplum Skirt
Peplum: Pleated decoration

With Ruffles

Waist Tuck
Tuck

With Vent
Back — Vent

*Vent refers to a slit at the hem. If there is only one, it is called a vent.

Flare Skirts

A skirt that has a gentle flare (like a morning glory) from the waist to the hem. A circular skirt creates that shape when the hem is spread out. It features vertical linear pleats that naturally flow downward due to the weight of the fabric. The starting position of the pleats is around the waist to the pelvis, and the difference in width with the hip line creates a snag in the fabric.

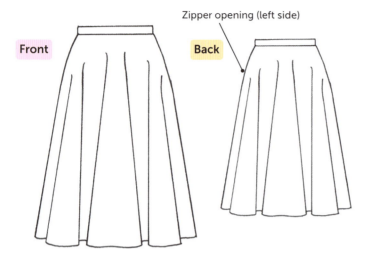

Front Back Zipper opening (left side)

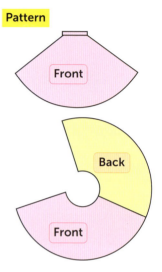

Pattern

Front / Back / Front

■ Circular Skirt (Four-piece Gored)

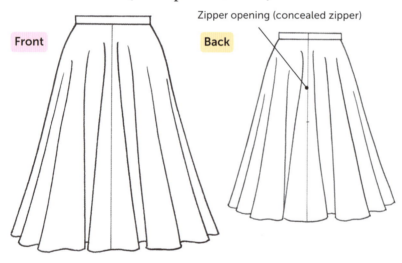

Front Back Zipper opening (concealed zipper)

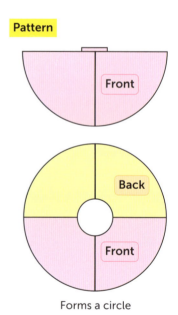

Pattern

Front / Back / Front

Forms a circle

■ Incorrect Drawing Method

The flare line is too curved.

▪ Mermaid Skirt

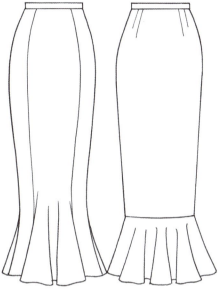

A silhouette resembling a mermaid.

▪ Gored Skirt

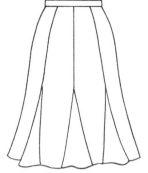

Features triangular gussets at the hem, which makes it flare out more than a tight skirt.

▪ Escargot Skirt (Spiral Skirt)

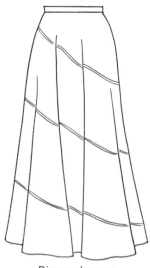

Diagonal seams.

▪ Handkerchief Hem Skirt

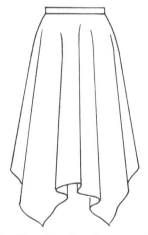

Characterized by a hemline that resembles a square piece of fabric hanging down like a handkerchief.

▪ Waist Yoke Construction

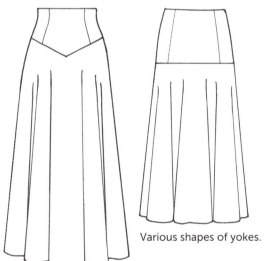

Various shapes of yokes.

▪ Fish Tail Skirt

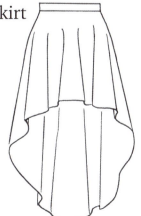

Refers to a skirt with a difference in length between the front and back.

▪ Variations Through Seaming

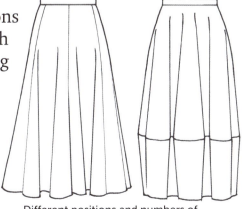

Different positions and numbers of seams (gores) depending on the design.

67

Gathered Skirts

A skirt that gathers fabric around the waist by sewing the fabric together to create billowy ruffles and volume.

In the case of a skirt with a belt, wrinkles are drawn starting from the line under the belt. Additionally, the number of wrinkles drawn changes according to the amount of gathering.

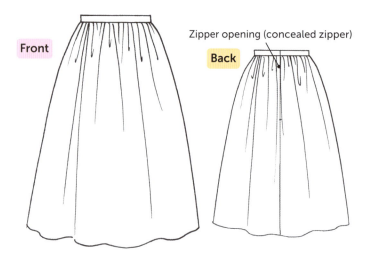

■ Tiered Skirt

This overlapping design features multiple layers of gathers or ruffles.

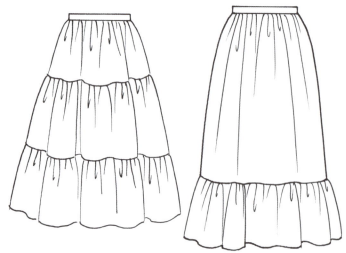

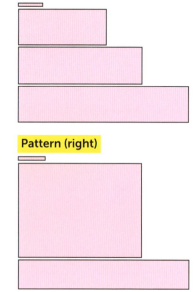

■ Incorrect Drawing Method

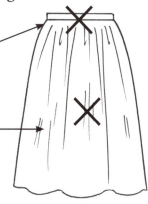

Gathering is not sewn down (in the case of a belt, the gathering should emerge from below the belt).

There are too many unnecessary lines (lines that are not connected or drawn without context are not needed).

The inside is too visible (the overall shape should be emphasized rather than just the hem).

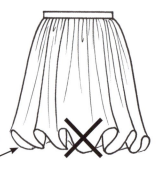

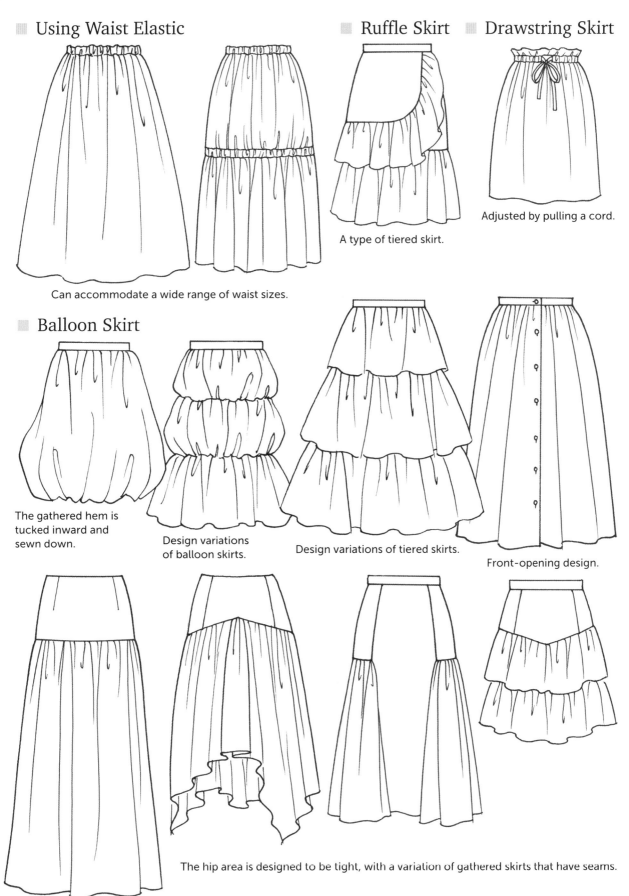

Pleated Skirts

This style is characterized by repeated vertical folds extending from the waist to the hem. Pleats are used for their decorative effect, adding dimension as well as for functional movement.

Pleats can vary in width and folding direction, with main types including one-way pleats, box pleats, inverted pleats, and accordion pleats. Additionally, the direction of the pleats can be indicated by the differences in the hemline.

■ One-Way Pleat Skirt

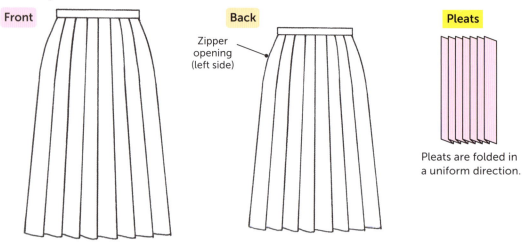

Pleats are folded in a uniform direction.

Even with the same silhouette, design options expand with different specifications.

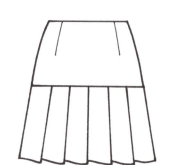

Cut at the waist yoke.

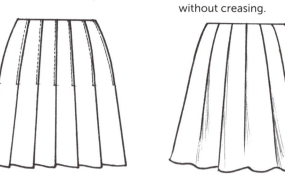

Sewn down to the hip line. Sewn down around the waist, without creasing.

■ Incorrect Drawing Method

No seams (since the fabric is folded, lines are needed even in closed areas).

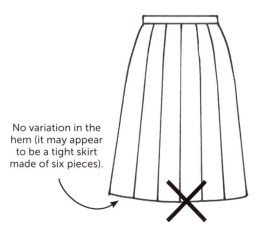

No variation in the hem (it may appear to be a tight skirt made of six pieces).

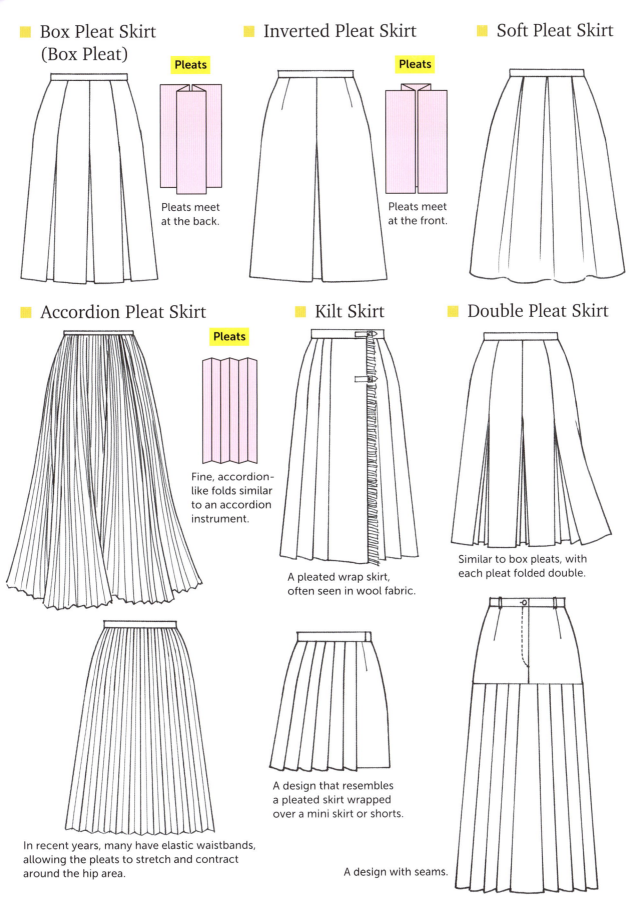

How to Draw a Skirt

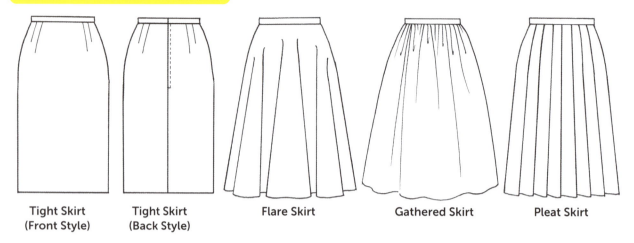

Tight Skirt (Front Style) | Tight Skirt (Back Style) | Flare Skirt | Gathered Skirt | Pleat Skirt

1. Tight Skirt

Front Style

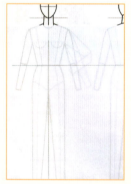

Use the body template for the illustration. Place a thin sheet of paper on top and draw the center line and waistline.

Draw a rectangular belt above the waistline. Determine the skirt length and lightly draw the hemline.

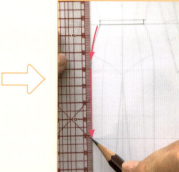

Curve the hip area, connecting the end of the curve with a straight line.

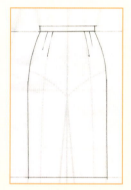

Draw two waist darts on each side.

Back Style

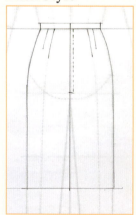

The silhouette is the same as the front style. Draw a back zipper opening and two darts on each side.

Final Draft (Common to All Illustrations)

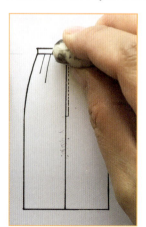

Finalize with a drawing pen (micron pen). Change the thickness for the main lines, darts, stitches, buttons, and other details to make them more readable. Here, use 0.5mm for the main lines and 0.1mm and 0.3mm for the details. Erase the pencil sketch with an eraser.

2. Flare Skirt

 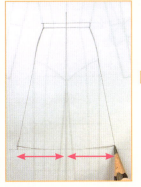 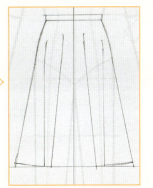 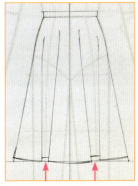

Shape the waist area to fit the human body and draw the side line with a straight line from the end of the curve.

Measure the hem and adjust the width on both sides. Draw the hemline with a gentle curve.

Draw the flare pleats symmetrically.

Creating a step in the hemline can express the depth of the pleats.

3. Gathered Skirt

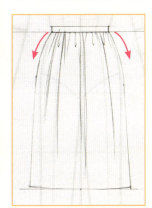

Create volume below the belt and draw the side line. Evenly draw the gathering line below the belt.

Connect the hem with a curve.

4. Pleat Skirt

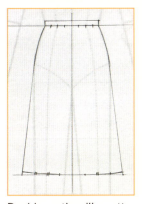 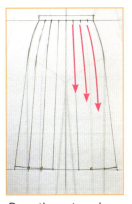 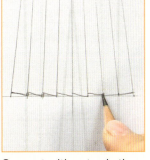 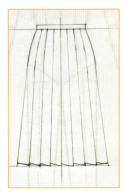

Decide on the silhouette and divide it based on the number of pleats seen from the front. Here, there are eight pleats.

Draw the outer edge with a curve to match the waist area.

Connect with a step in the hemline.

73

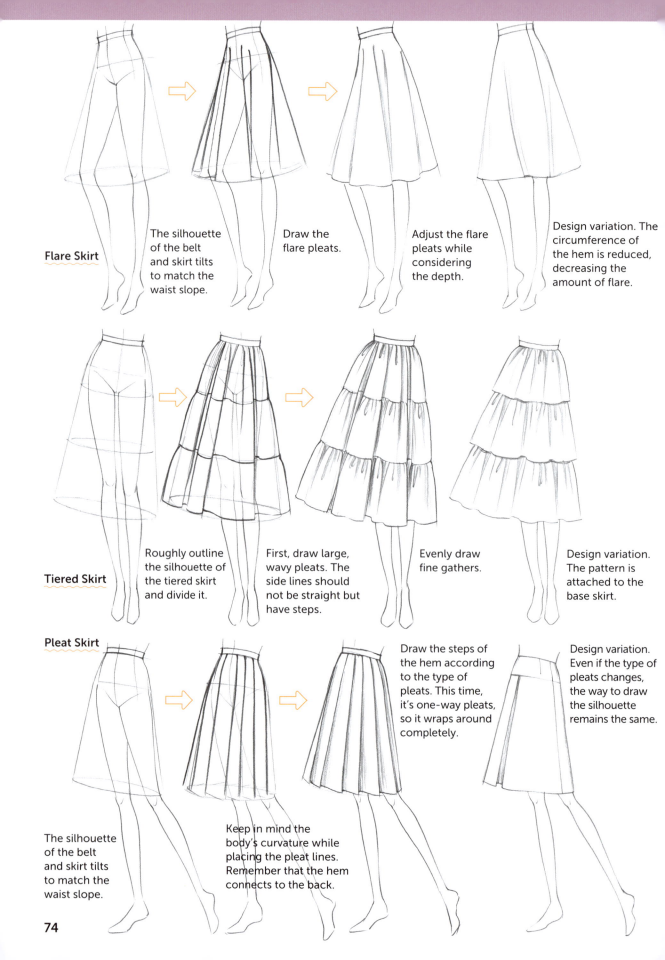

Skirt Styles

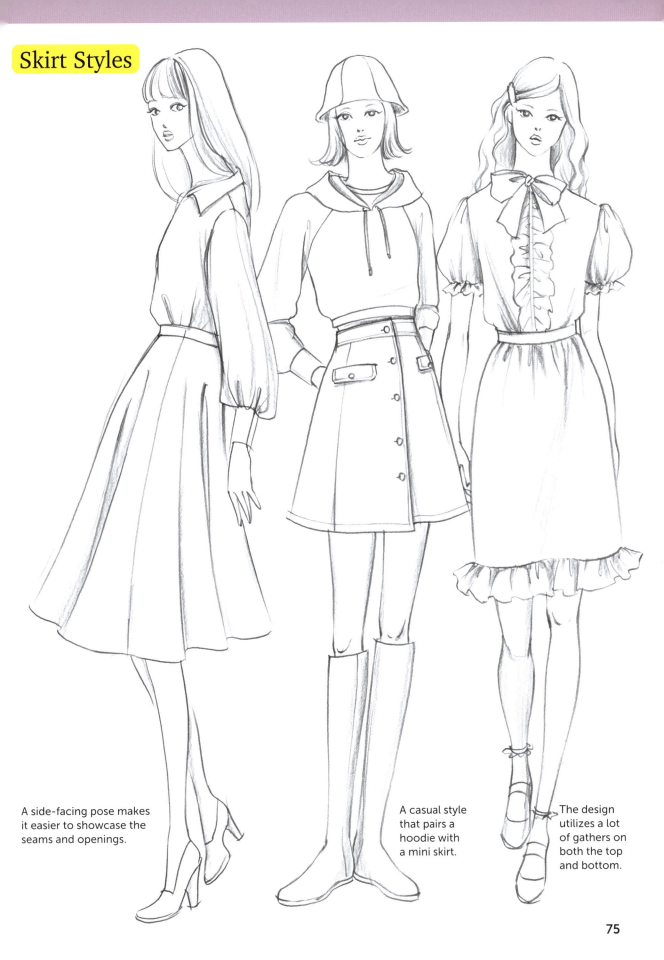

A side-facing pose makes it easier to showcase the seams and openings.

A casual style that pairs a hoodie with a mini skirt.

The design utilizes a lot of gathers on both the top and bottom.

75

Pants

Pant Specifications

Pants are made by sewing together cylindrical left and right legs at the crotch. The overall impression is determined by the silhouette and the length of the pants, but attention should also be paid to details such as openings and pockets.
- Position of openings: front opening, side opening, elastic waistband
- Presence and number of darts or tucks
- Presence and type of pockets (side pockets, hip pockets)

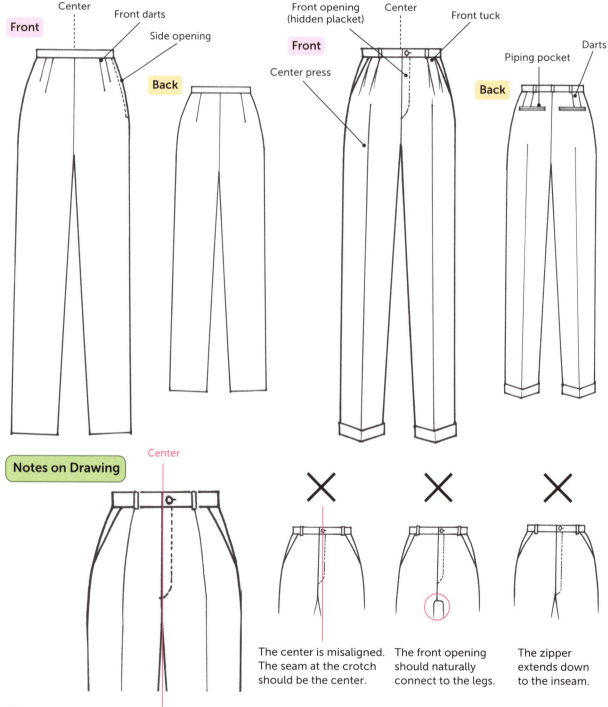

Pant Silhouettes

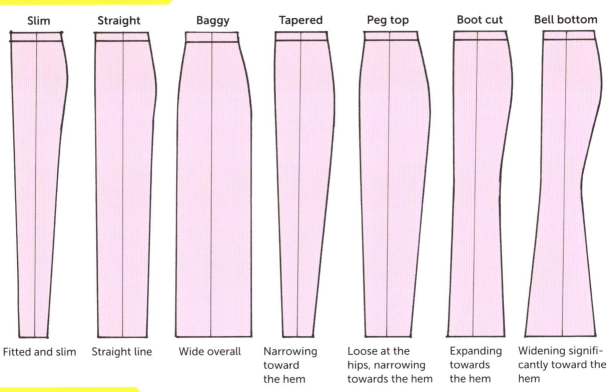

Slim	Straight	Baggy	Tapered	Peg top	Boot cut	Bell bottom
Fitted and slim	Straight line	Wide overall	Narrowing toward the hem	Loose at the hips, narrowing towards the hem	Expanding towards the hem	Widening significantly toward the hem

Pant Lengths

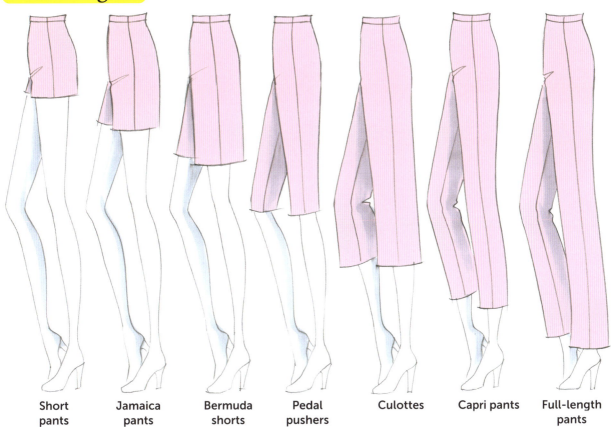

Short pants · Jamaica pants · Bermuda shorts · Pedal pushers · Culottes · Capri pants · Full-length pants

How to Draw Pants

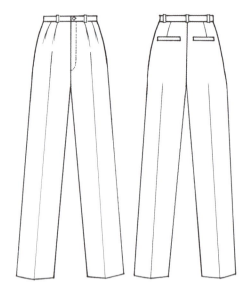

1

Use the body of the item illustration as a base. Place a thin sheet of paper on top and draw the center line and waistline.

Draw the belt above the waistline (for just waist). The front opening and the crotch line will be the center.

2

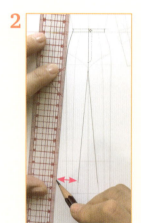

Determine the length of the pants and the width of the hem. Draw the inner and outer lines.

3

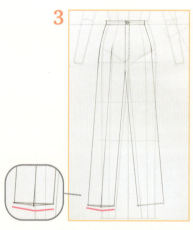

Draw the center press line and create a fold at the hem.

4

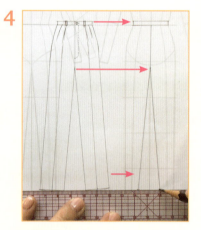

Back Style
Continue ensuring the size remains the same as the front style by marking with a ruler. The silhouette is the same.

5 Draw details for both the front and back.

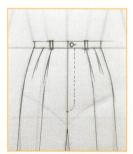

Front: opening, tucks, belt loops

Back: hip pockets, darts, belt loops

6

Finalize the drawing with a drawing pen and erase the underdrawing.

Pant Styles

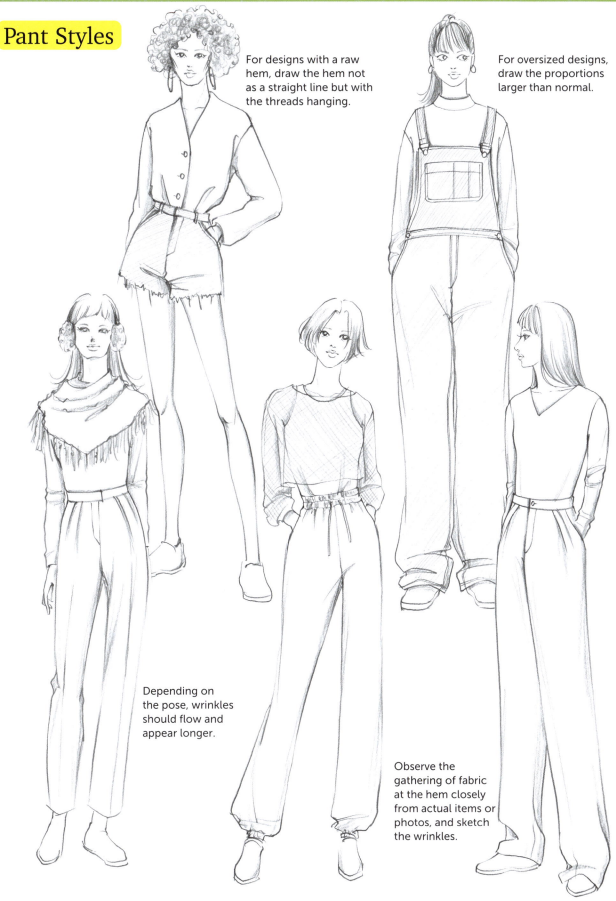

For designs with a raw hem, draw the hem not as a straight line but with the threads hanging.

For oversized designs, draw the proportions larger than normal.

Depending on the pose, wrinkles should flow and appear longer.

Observe the gathering of fabric at the hem closely from actual items or photos, and sketch the wrinkles.

Types of Pants

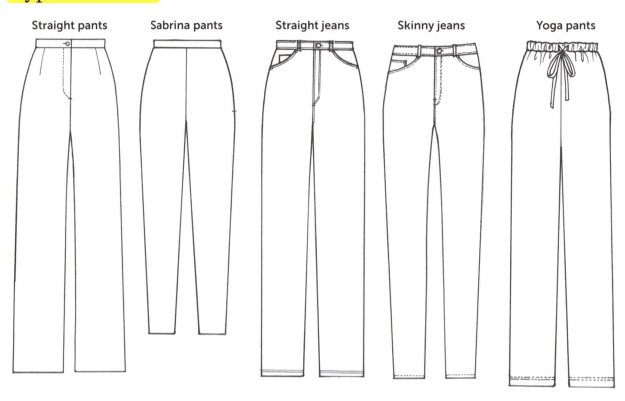

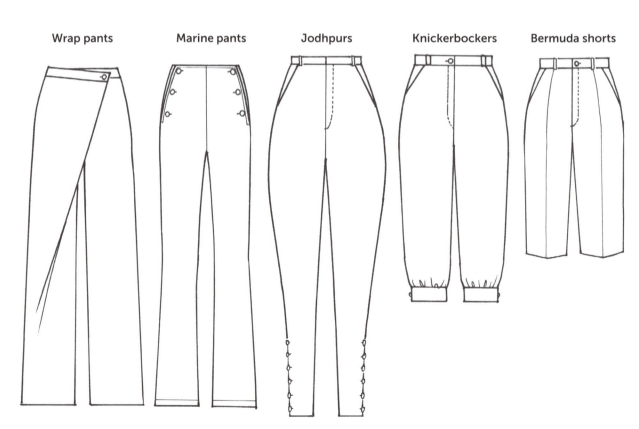

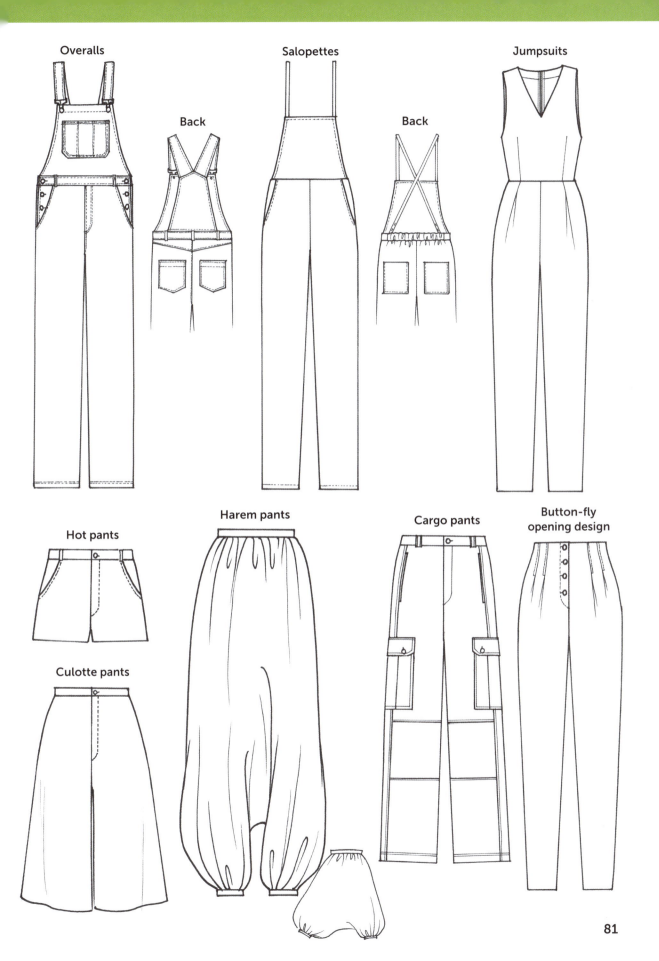

Shirts and Blouses

Shirts

Dress shirts were originally made to be worn under men's jackets. They have a front opening, collar, sleeves, and cuffs. The buttons on the front opening of men's shirts are on the right side, while the buttons on women's shirts are on the left.

Blouses

Blouses are designed as outerwear for women to be worn alone. There are no specific design rules, and they may feature decorations such as lace, ruffles, or embroidery. There's a wide variety of fabrics and colors available.

Shirts with a Stand Collar

Women's Shirt

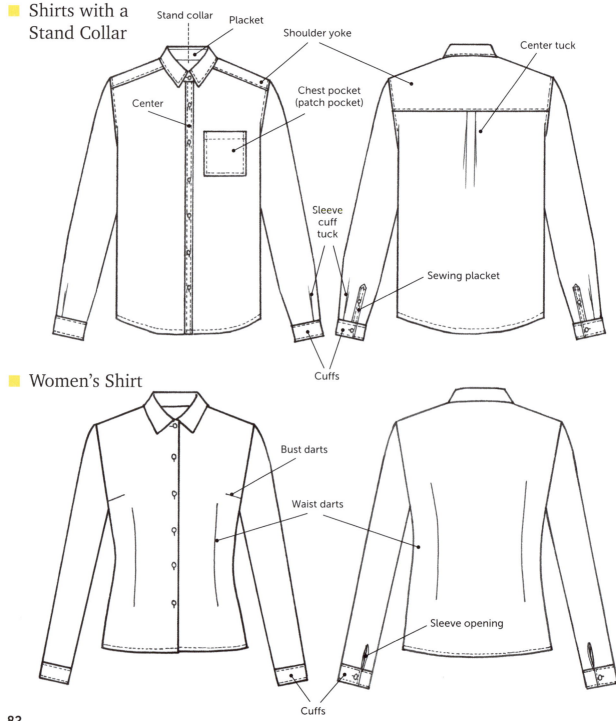

Variations of Dress Shirt Collars

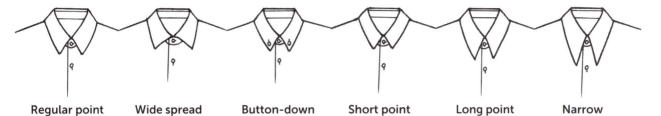

Cuffs

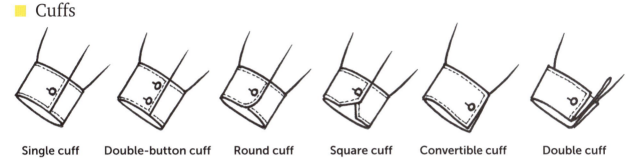

Back Design

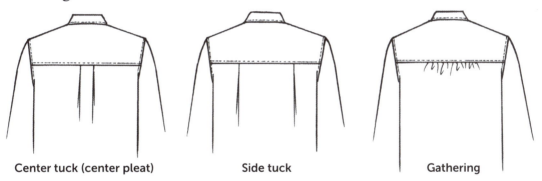

Sleeve Opening

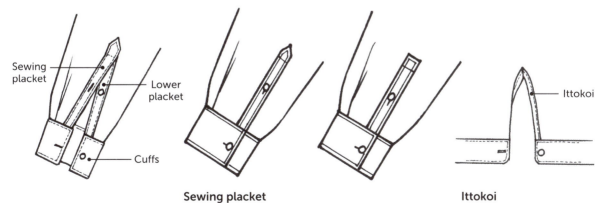

Sewing placket
The end of the piece has a shape resembling the tip of a sword, though some design variations can be seen.

Ittokoi
One method of processing the sleeve opening.

Types of Shirts and Blouses

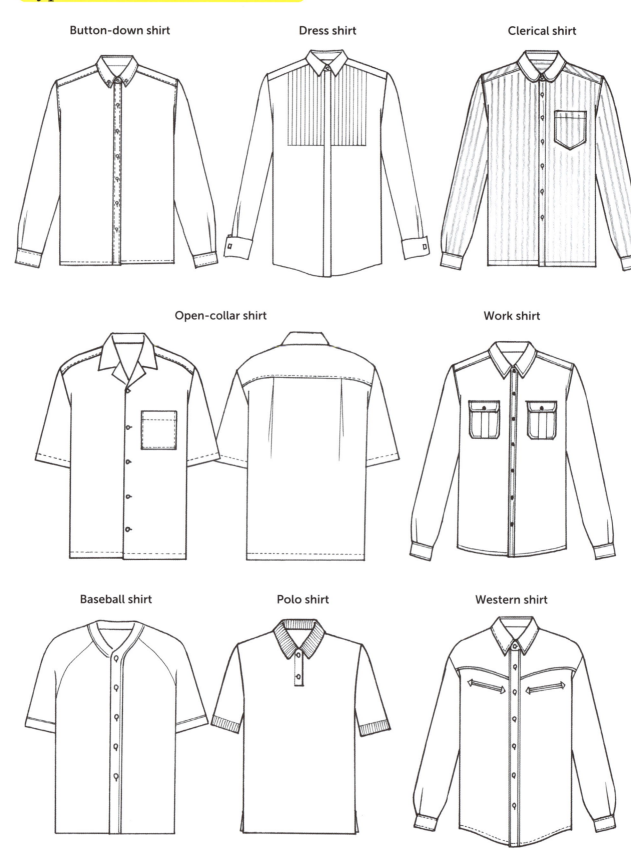

Variations of Blouses

Generally, blouse designs vary widely, and many feature details such as frills, lace, and smocking.

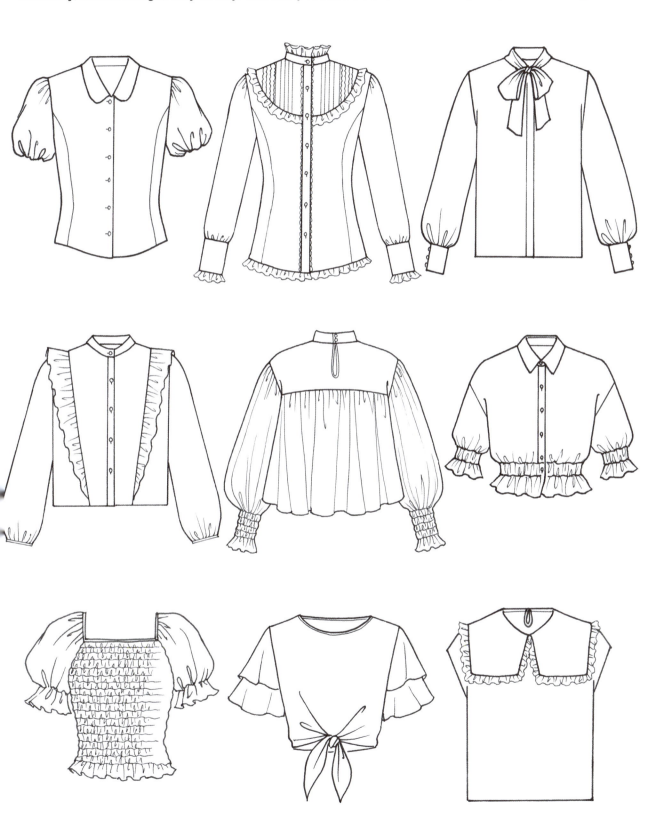

How to Draw a Shirt

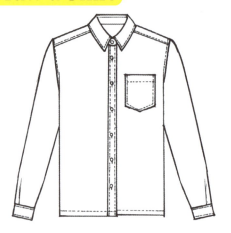
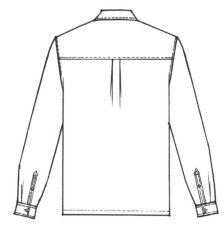

1 How to Draw Shirt Illustrations

Use a body outline for the illustration. Place a thin sheet of paper on top, and draw the center line and waistline.

2 Draw the Collar of the Shirt

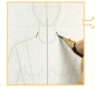 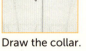

Decide on the height of the collar. → Draw the line for the back neckline. → Draw the line for the front neckline. → Draw the collar.

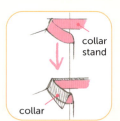

collar stand

collar

Draw the seam between the collar stand and the collar.

Draw the seam between the back bodice and the collar stand.

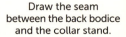

Draw the seams.

3 Draw the Bodice

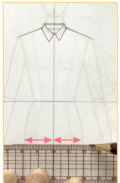
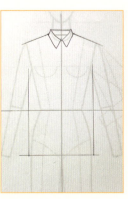

Decide on the length, measuring equally from the center to ensure the width is symmetrical.

Draw the side line and shoulder line.

4 Draw the Placket, Buttons, and Shoulder Yoke

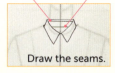

Draw the collar stand.

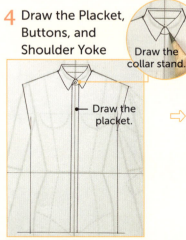

Draw the placket.

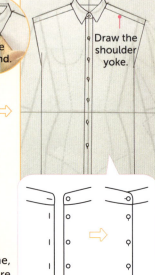

Draw the shoulder yoke.

Placement is key.

Draw the buttons and buttonholes (this time, seven buttons). Generally, the buttonholes on shirts are horizontal on the collar stand and vertical on the bodice.

5 Draw the Sleeves

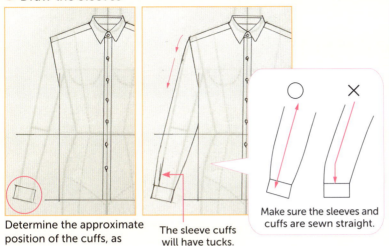
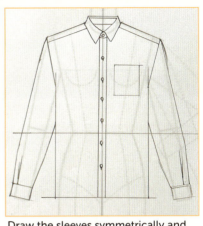

Determine the approximate position of the cuffs, as this will help you visualize the sleeve width, making it easier to draw.

The sleeve cuffs will have tucks.

Make sure the sleeves and cuffs are sewn straight.

Draw the sleeves symmetrically and add the chest pocket (patch pocket).

6 Draw the Back Style

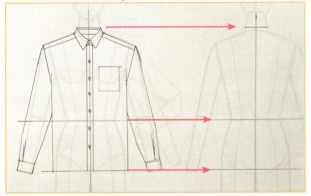
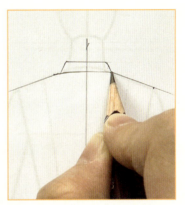

Place a ruler parallel to the front style to mark the positions. Be careful to maintain consistent lengths and widths between the front and back.

Draw the collar and smoothly connect it to the shoulder line in the center.

7 Draw the Back Bodice

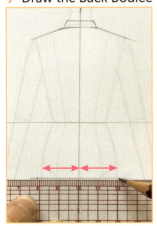
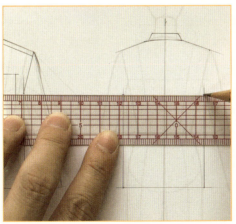
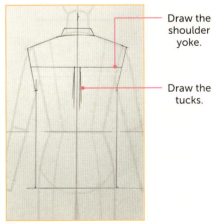

Measure the bodice width equally from the center to both sides.

Draw the side line and connect the underarm position of the armhole to match the front style.

Draw the shoulder yoke and tucks.

Draw the shoulder yoke.

Draw the tucks.

87

8 Draw the Sleeves from the Back

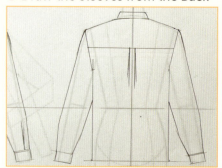
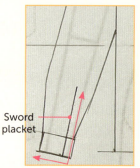

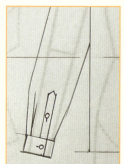

Draw the sleeves to match the silhouette of the front style.

Determine the position of the sword placket. It should be vertical to the cuff.

Draw the sword placket.

There is also one tuck on the back side. The buttonhole should be vertical for the sword placket and horizontal for the cuff.

9 Inking (Finalization)

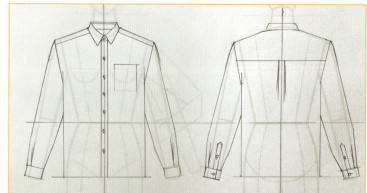

The pencil drawing is complete. Now, ink it to finalize.

Using different pen thicknesses for main lines and details makes it easier to see:
- Main lines: 0.5mm or 0.3mm
- For buttons, tucks, stitches, etc.: 0.1mm or 0.05mm

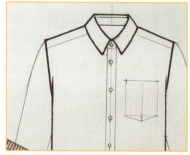
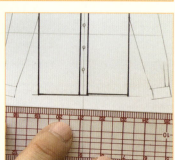

Add a step to include the details on the front.

Start drawing from the main lines.

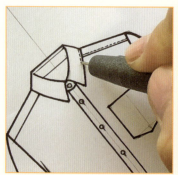
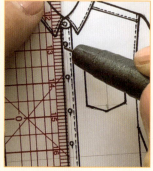
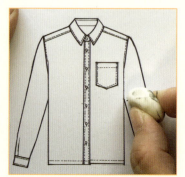

Don't forget to add the stitches.

Using a ruler helps to draw straight lines.

Erase the pencil sketch to complete.

Shirt and Blouse Styles

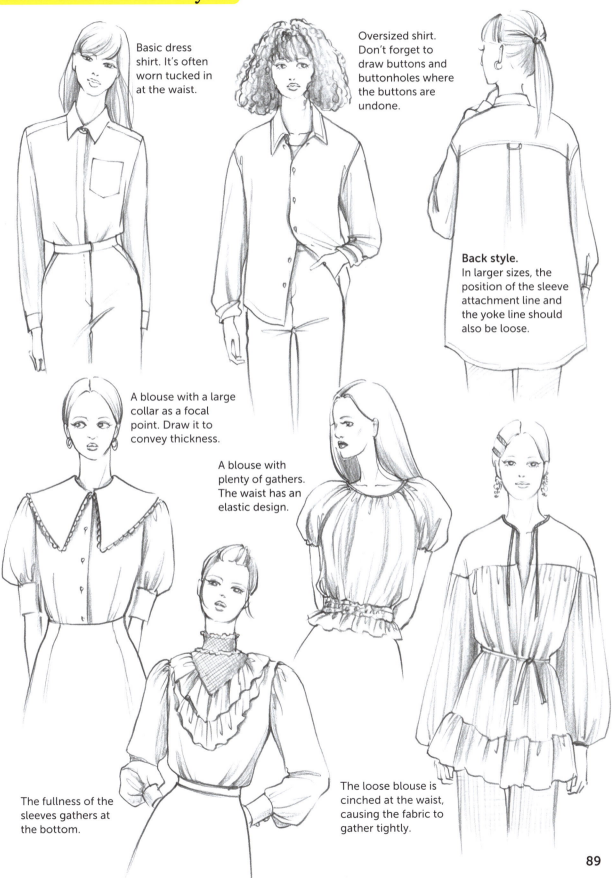

Basic dress shirt. It's often worn tucked in at the waist.

Oversized shirt. Don't forget to draw buttons and buttonholes where the buttons are undone.

Back style. In larger sizes, the position of the sleeve attachment line and the yoke line should also be loose.

A blouse with a large collar as a focal point. Draw it to convey thickness.

A blouse with plenty of gathers. The waist has an elastic design.

The fullness of the sleeves gathers at the bottom.

The loose blouse is cinched at the waist, causing the fabric to gather tightly.

89

One-Piece Dresses

What Is a One-Piece Dress?

Typically, a one-piece dress is worn as a single garment. However, it doesn't necessarily mean that the top and bottom are made from the same fabric; designs with different colors or contrasting materials add variety to the outfits you come up with. One-piece dresses feature numerous design elements. Let's go through the essential points in order.

■ Types of Silhouettes

Since a one-piece dress covers a large area of the body, the overall silhouette (line) is a crucial aspect. Based on the silhouette, you can incorporate design details such as seams, sleeves, and collars.

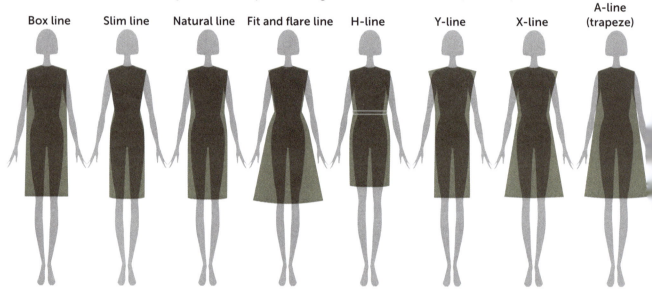

■ Variations Through Waistline Seams

By adding a seam at the waistline, more intricate details or patterns can be applied to both the top and skirt. Additionally, you can create designs that use different fabrics for the upper and lower parts.

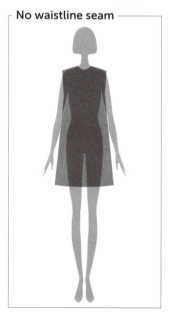
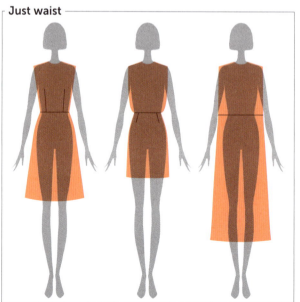
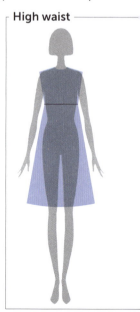

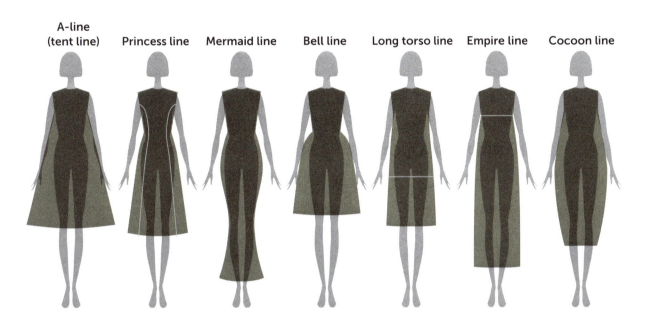

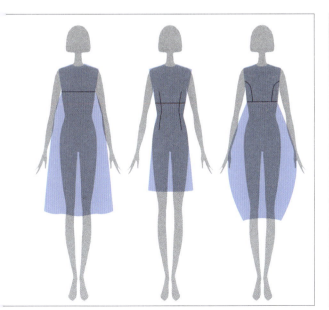

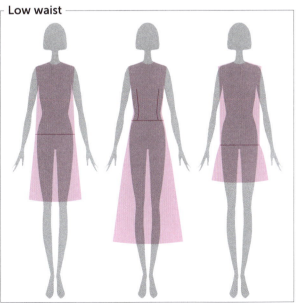

Once the silhouette is determined, the next step is to think about the details.

At first glance, the two dresses below may seem fine, but with this construction, they cannot actually be worn.

Here, we'll consider variations based on the combination of a sleeveless, collarless top and a gathered skirt.

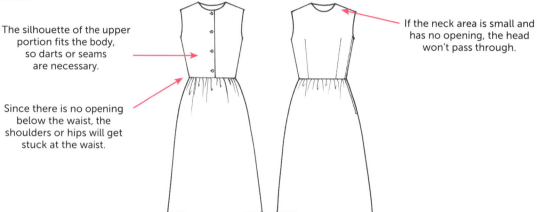

The silhouette of the upper portion fits the body, so darts or seams are necessary.

Since there is no opening below the waist, the shoulders or hips will get stuck at the waist.

If the neck area is small and has no opening, the head won't pass through.

■ Types and Positions of Openings

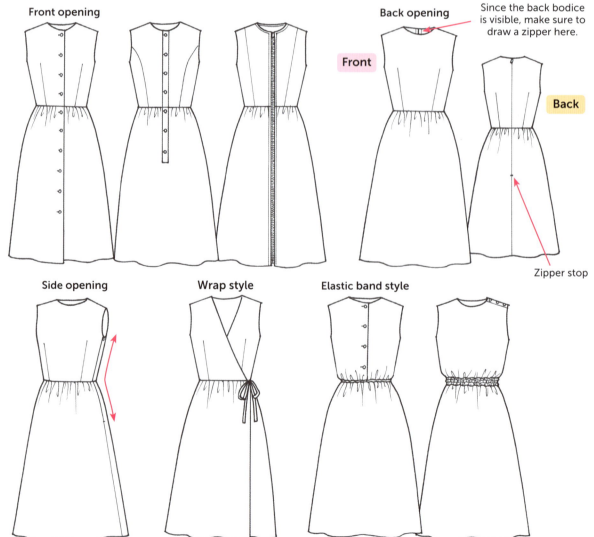

Since the back bodice is visible, make sure to draw a zipper here.

Zipper stop

- Add a Collar (Neckline) and Sleeves to the Design While Keeping the Skirt the Same

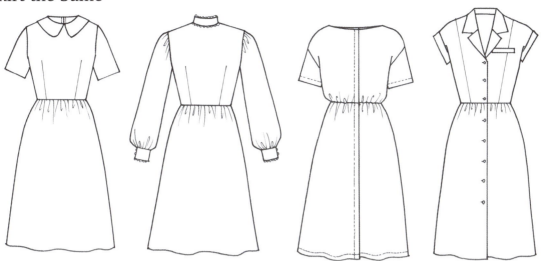

- Keep the Top as It Is, But Change the Design of the Skirt

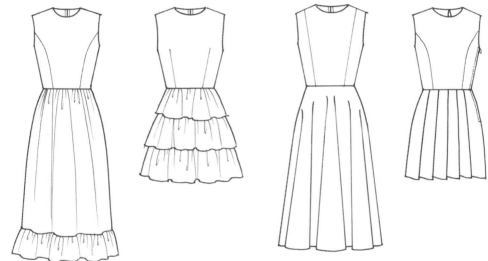

- Change the Position of the Waistline

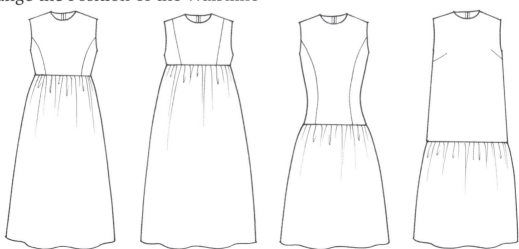

One-Piece Dress Design Variations

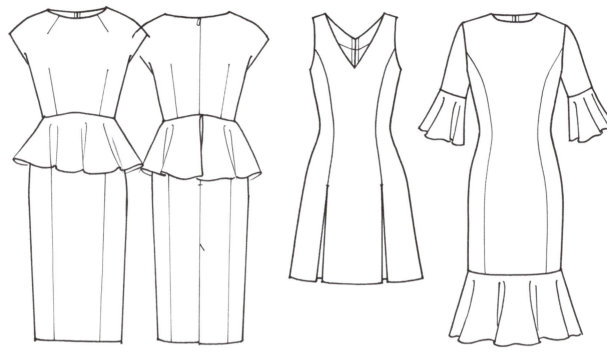

Make sure to include an opening in the peplum for the back style.

A design with princess seam lines.

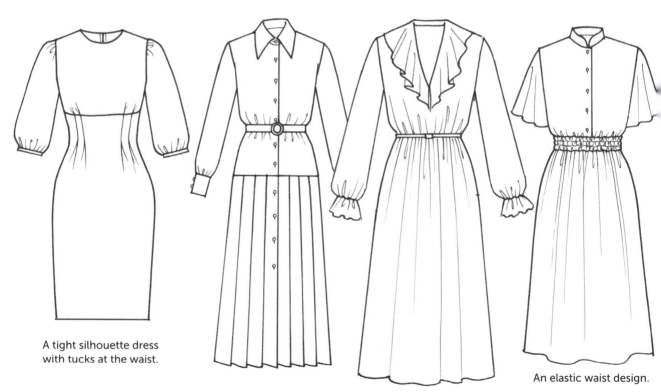

A tight silhouette dress with tucks at the waist.

With the attached belt. Sometimes, it's omitted if the drawing is only conveying the specifications of the dress.

An elastic waist design.

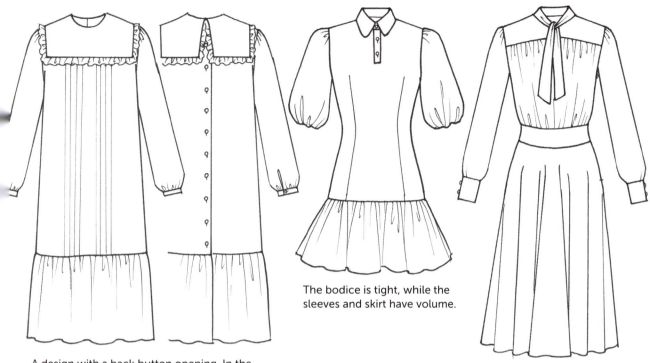

A design with a back button opening. In the back view, also draw the sleeve openings.

The bodice is tight, while the sleeves and skirt have volume.

An elegant design with gathers at the bust and plenty of pleats in the circular skirt. A zipper opening is placed on the left side.

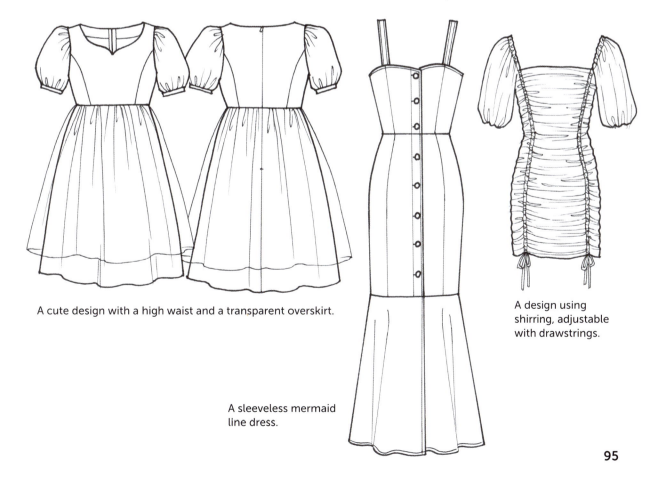

A cute design with a high waist and a transparent overskirt.

A sleeveless mermaid line dress.

A design using shirring, adjustable with drawstrings.

One-Piece Dress Styles

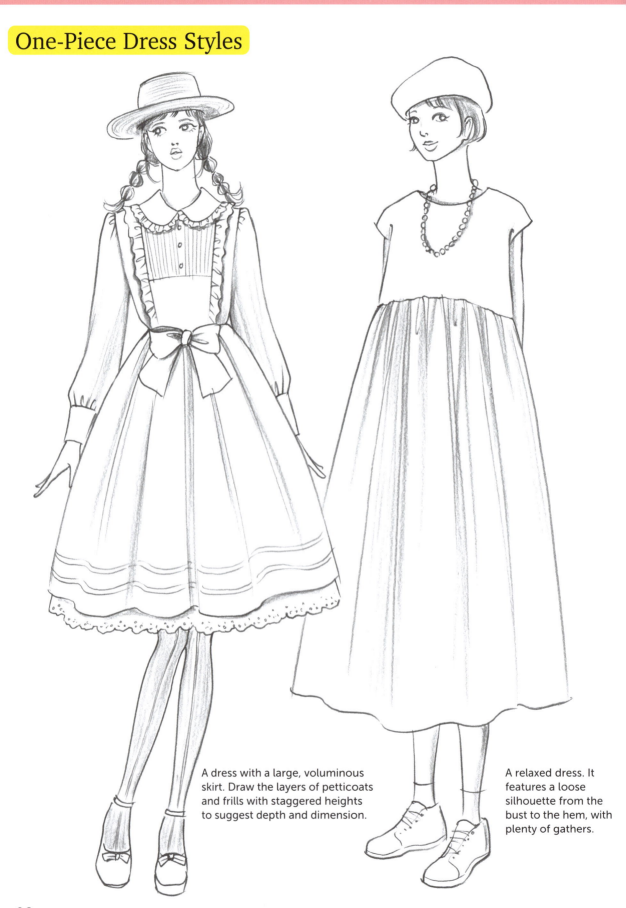

A dress with a large, voluminous skirt. Draw the layers of petticoats and frills with staggered heights to suggest depth and dimension.

A relaxed dress. It features a loose silhouette from the bust to the hem, with plenty of gathers.

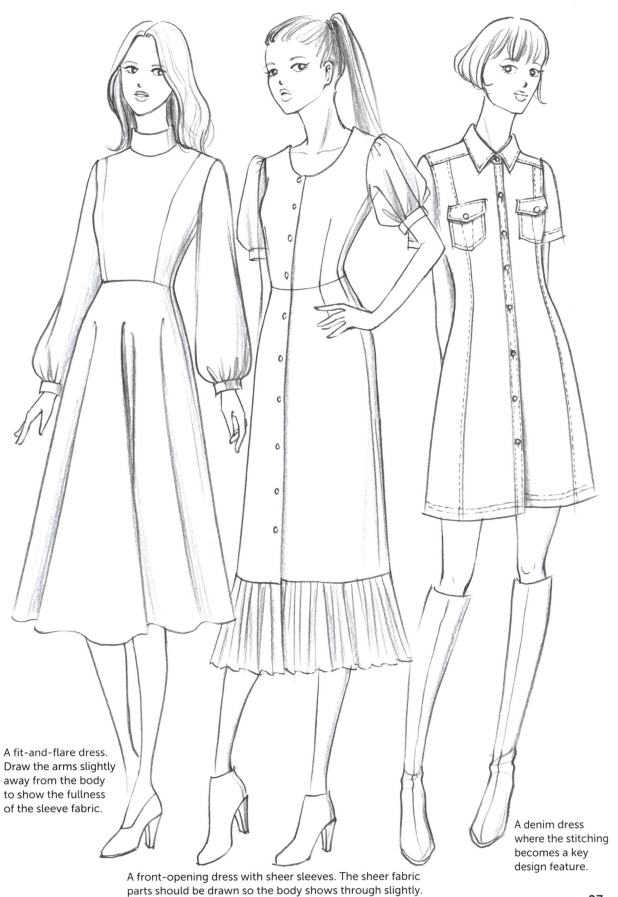

A fit-and-flare dress. Draw the arms slightly away from the body to show the fullness of the sleeve fabric.

A front-opening dress with sheer sleeves. The sheer fabric parts should be drawn so the body shows through slightly.

A denim dress where the stitching becomes a key design feature.

Jacket / Coat

Structure and Details of a Tailored Jacket

A tailored jacket is similar to a blazer. As styles have become less formal, jackets are often worn as casual attire. Typically, the term "tailored jacket" refers to the jacket alone, distinguishing it from a suit jacket.

▪ Notched Lapel (Single-Breasted) Waist Darts

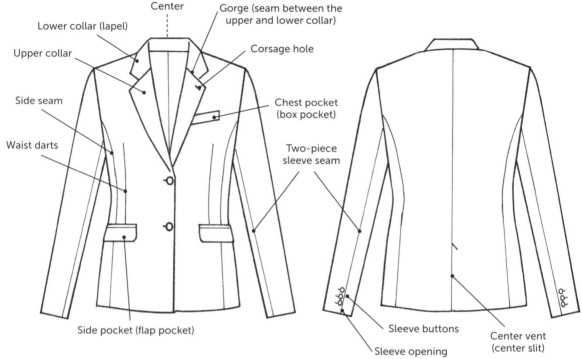

▪ Peaked Lapel (Double-Breasted)

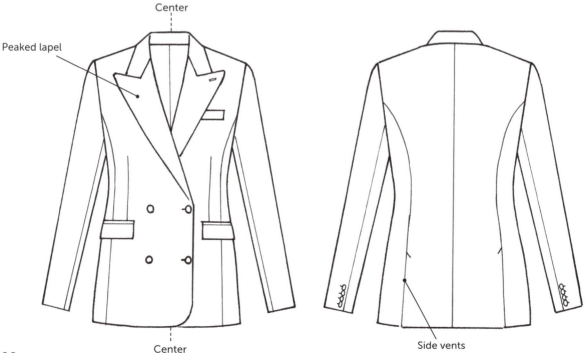

Collar Variations

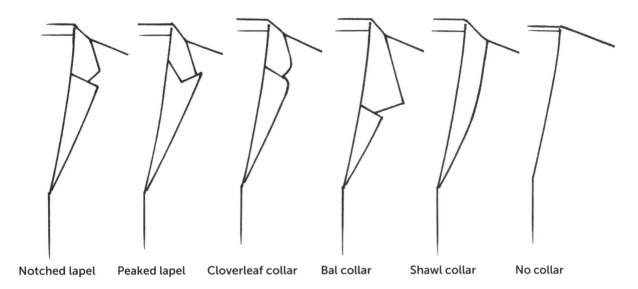

Button Variations

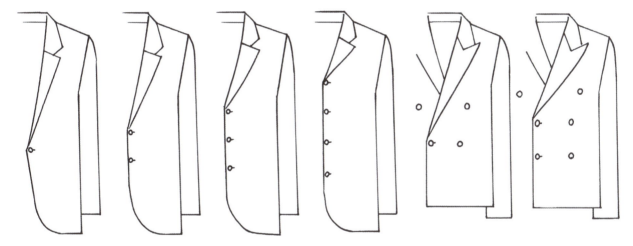

Cuff Styles

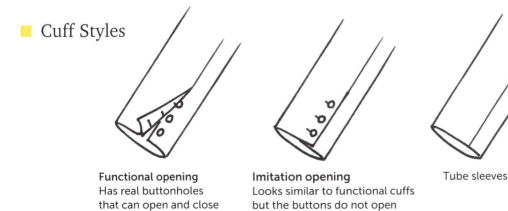

How to Draw a Jacket

■ Single Button, Notched Lapel

Here, layers are added to the body and drawn digitally. The same method applies for analog drawing.

1 Decide the position of the first button.

2 Draw the curve of the collar.

3 Draw the lapel (lower collar).

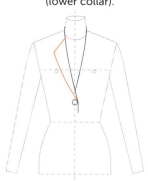

4 Draw the upper collar, paying attention to the folded part.

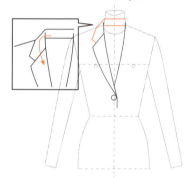

5 Draw the collar symmetrically.

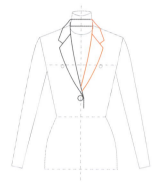

6 Draw the curve slightly above the waistline to create a beautiful silhouette when worn.

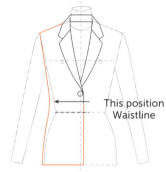

This position Waistline

7 Draw the other side of the body, the second button, and the buttonhole.

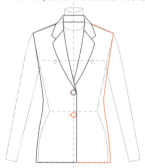

8 Draw the pockets (in this case, flap pockets).

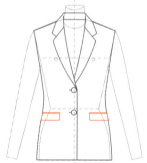

9 Draw the darts and the center back seam.

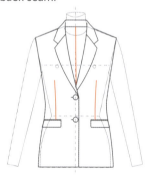

10 Draw the sleeves, ensuring the sleeve caps are not too angled.

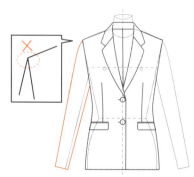

11 Since it's a two-piece sleeve, draw the seam. Complete both sleeves, and the illustration is finished.

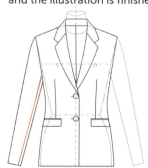

Complete.

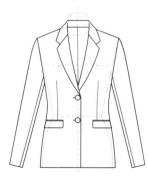

Double Button, Peaked Lapel

1 Decide the position of the first button.

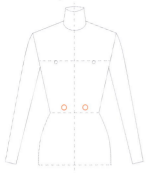

2 Draw the curve of the collar.

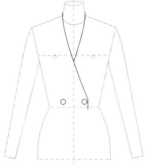

3 Draw the lapel (lower collar).

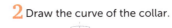

4 Draw the upper collar, paying attention to the folded part.

Note: This part is often attached.

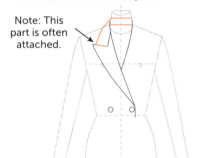

5 Draw the collar symmetrically.

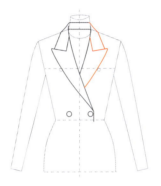

6 Draw the curve slightly above the waistline to create a beautiful silhouette when worn.

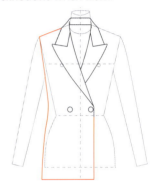

7 Draw the other side of the body, the second button, and the buttonhole (only on the overlap side).

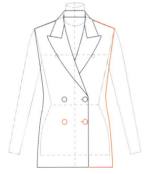

8 Draw the pockets (in this case, flap pockets).

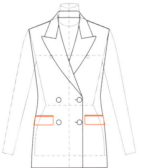

9 Draw the darts and the center back seam.

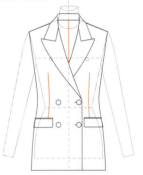

10 Draw the sleeves, ensuring the sleeve caps are not too angular.

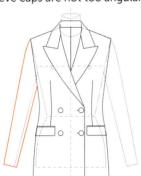

11 Since it's a two-piece sleeve, draw the seam. Complete both sleeves, and the illustration is finished.

Complete.

101

Jacket Design Variations

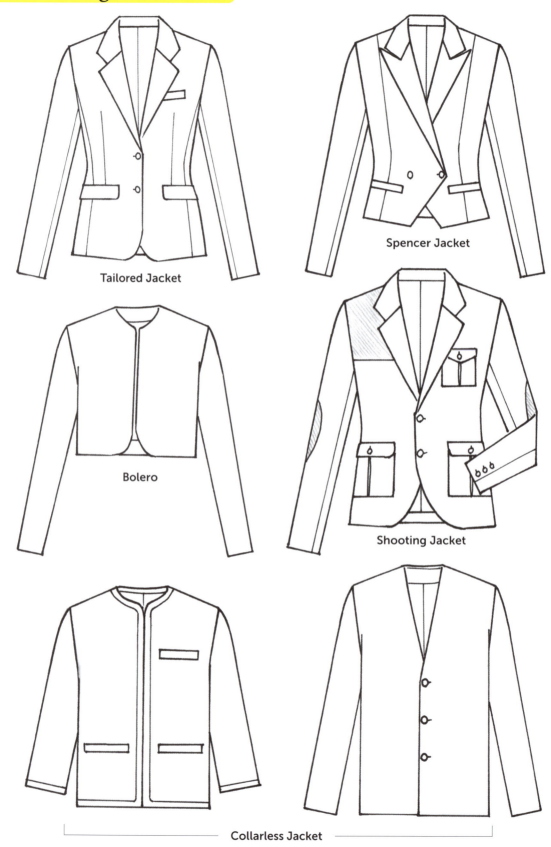

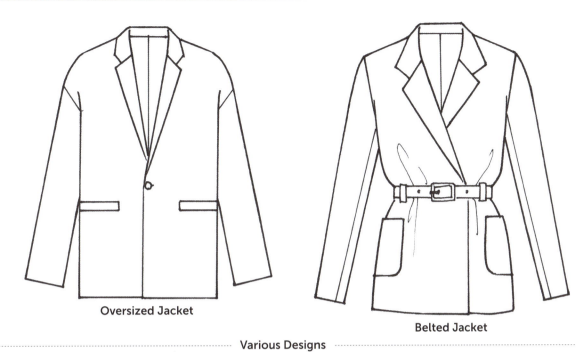

Oversized Jacket

Belted Jacket

Various Designs

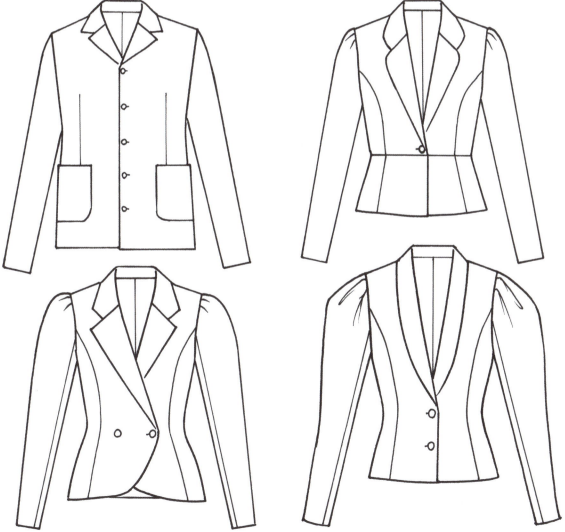

Jacket Styles

An open-front style, the fabric moves backward, creating space between the body and the jacket.

Consider the thickness of the fabric and draw a soft, rounded line above and below the belt.

A jacket with a straight shoulder line and a structured silhouette.

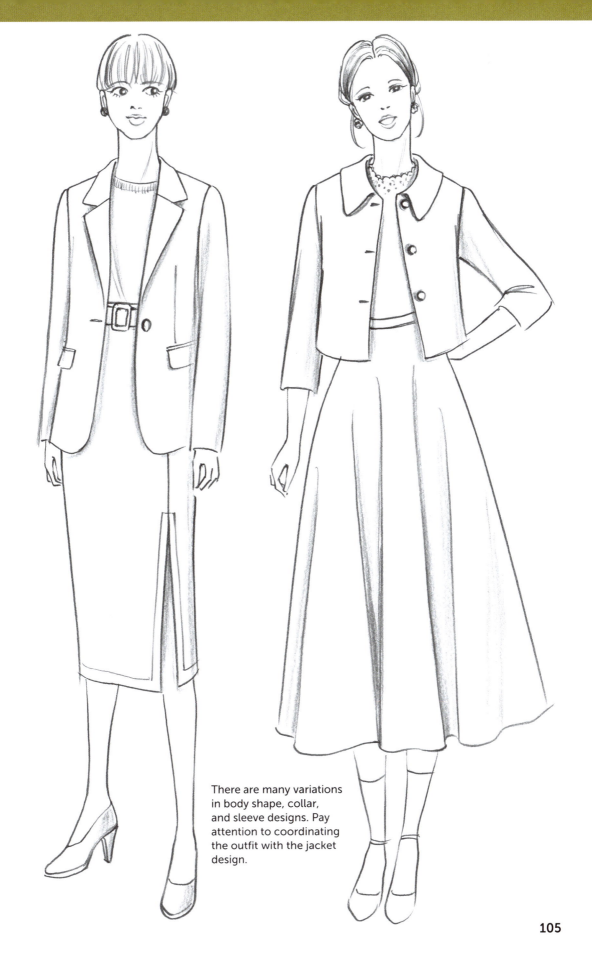

There are many variations in body shape, collar, and sleeve designs. Pay attention to coordinating the outfit with the jacket design.

Coat Design Variations

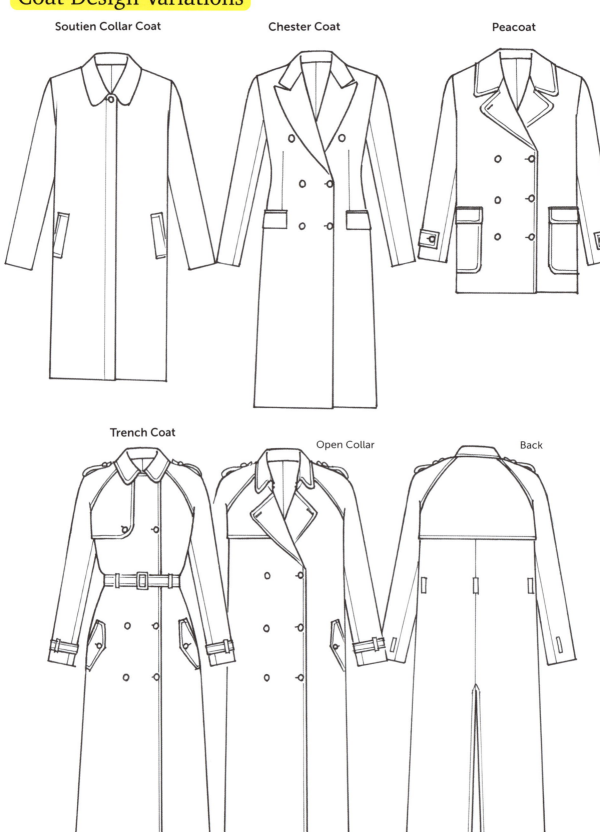

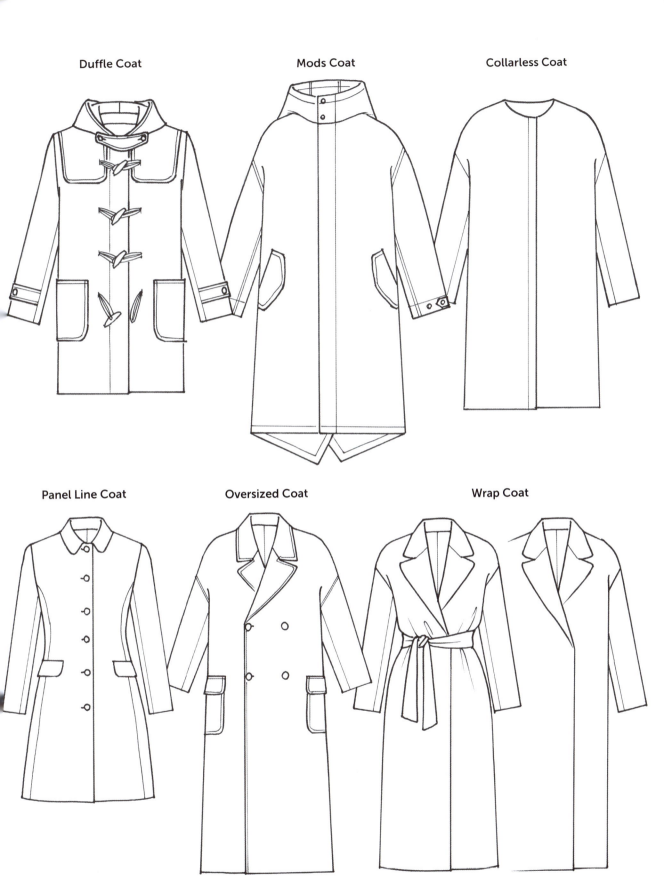

Coat Styles

By making the area above and below the belt fuller, the thickness of the fabric is emphasized.

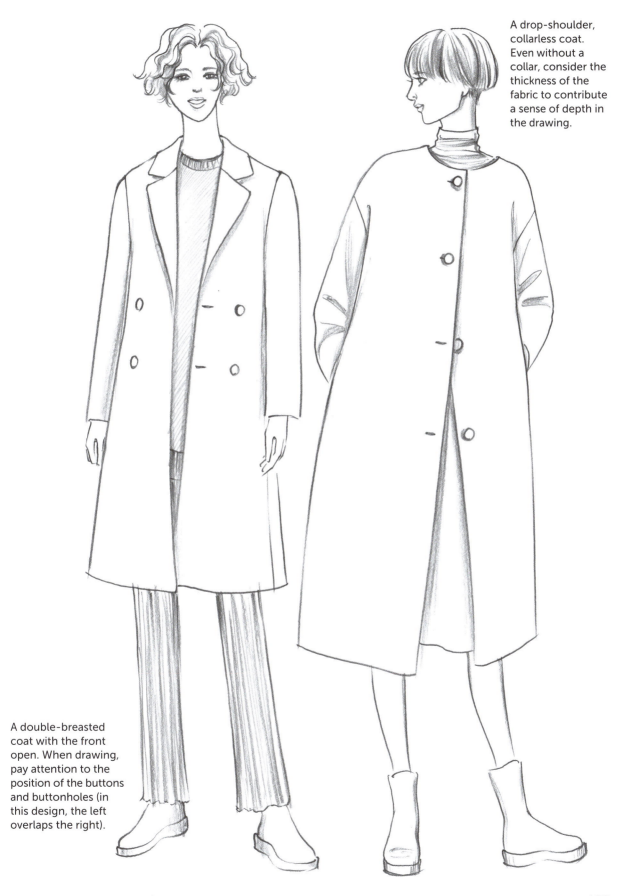

A drop-shoulder, collarless coat. Even without a collar, consider the thickness of the fabric to contribute a sense of depth in the drawing.

A double-breasted coat with the front open. When drawing, pay attention to the position of the buttons and buttonholes (in this design, the left overlaps the right).

A coat with accentuated stitching. Be mindful of the thickness in areas such as the pockets and sleeve cuffs.

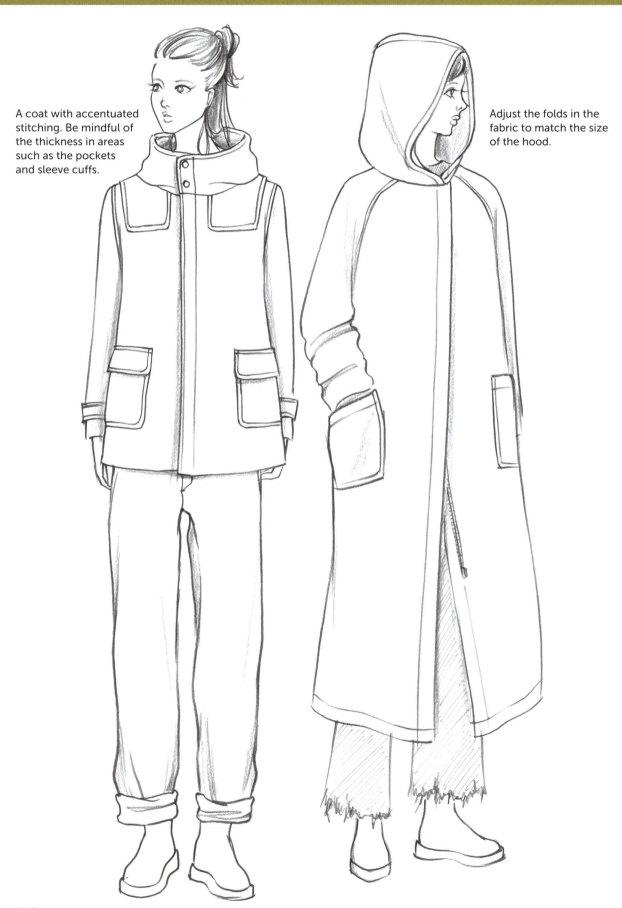

Adjust the folds in the fabric to match the size of the hood.

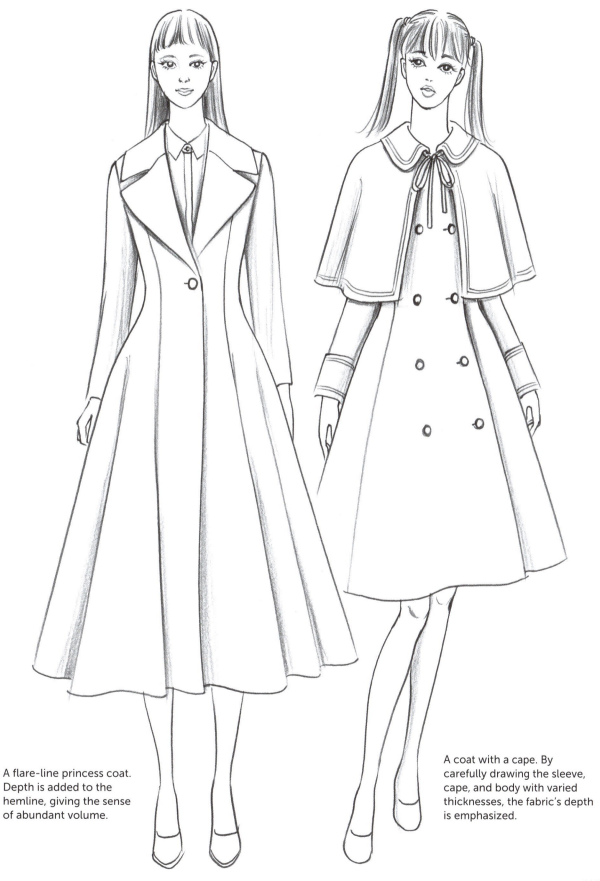

A flare-line princess coat. Depth is added to the hemline, giving the sense of abundant volume.

A coat with a cape. By carefully drawing the sleeve, cape, and body with varied thicknesses, the fabric's depth is emphasized.

Types of Jackets

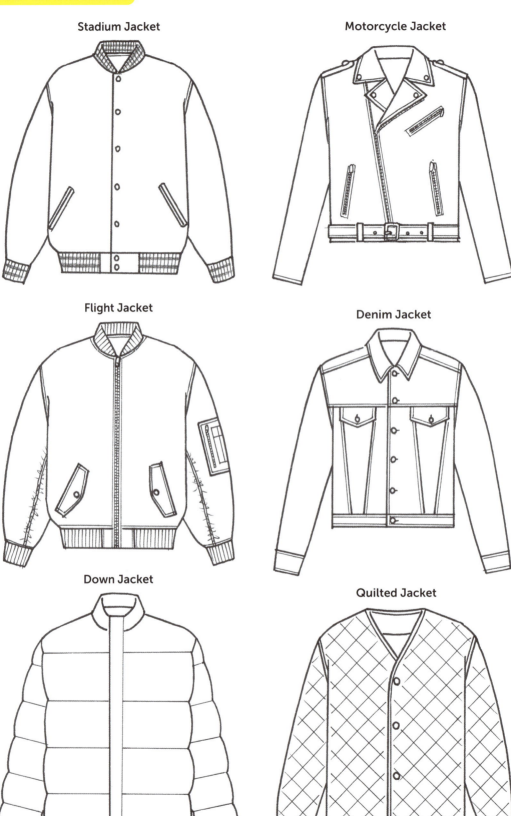

Knitwear

Other Items

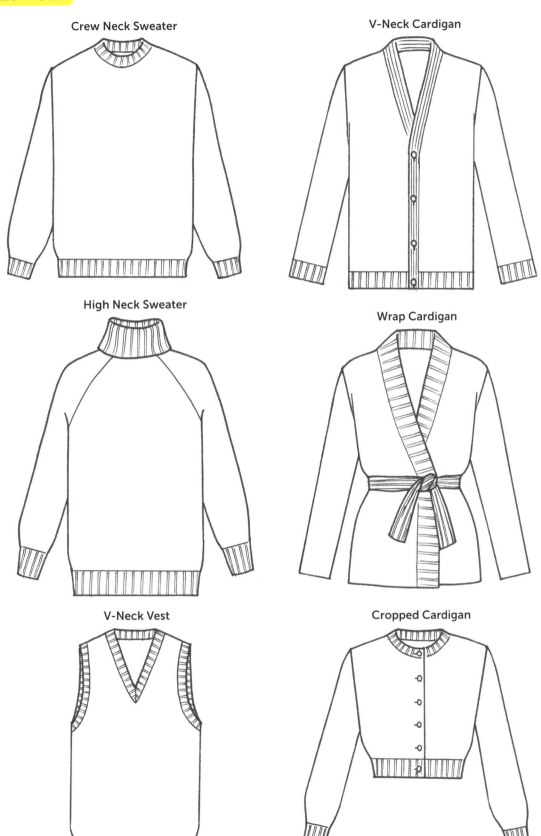

Cut and Sewn

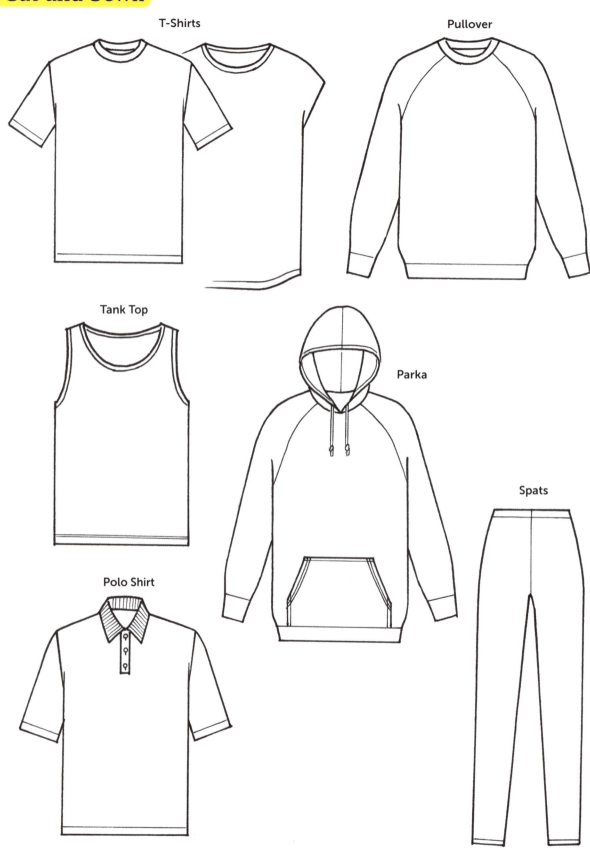

Underwear

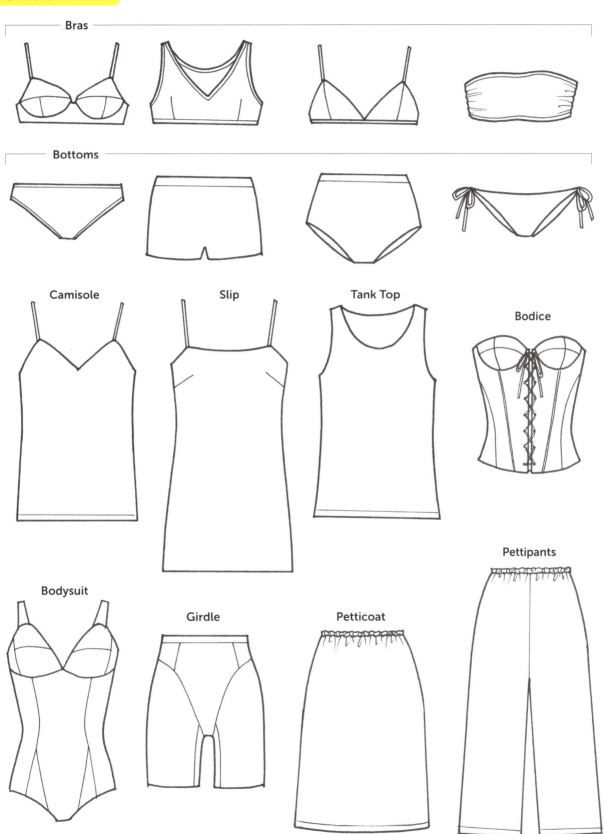

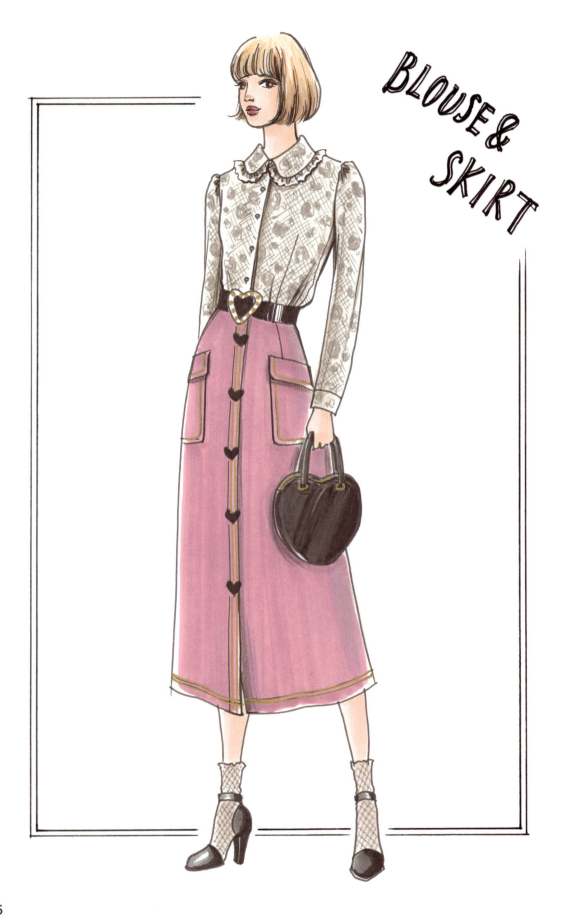

4

Getting Creative with Color

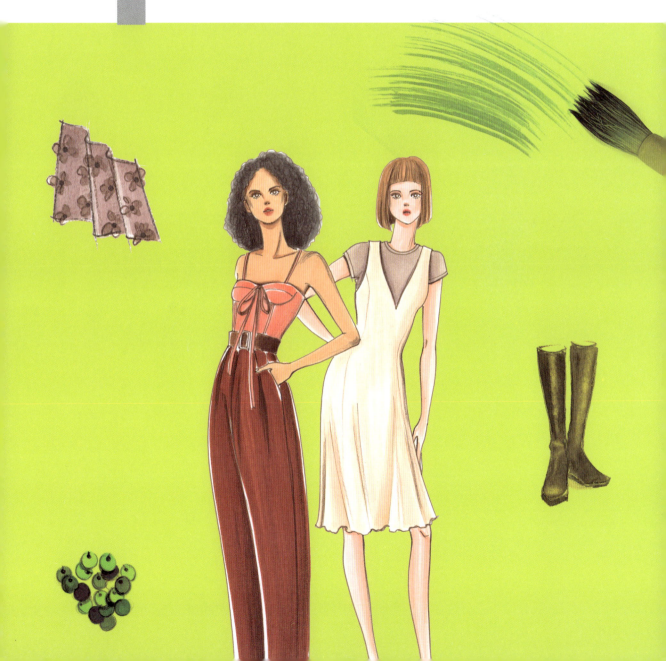

Whiteout Techniques

This method of painting omits color in bright areas that are exposed to light, leaving the white of the paper. The advantage of this method is that it produces a light finish and makes it easy to see the underlying structural lines after coloring. Some materials make it difficult to suggest the sense of heaviness, so increase the area of coloring or apply layers of paint as needed.

▪ Skin Tone

Watercolor

Markers

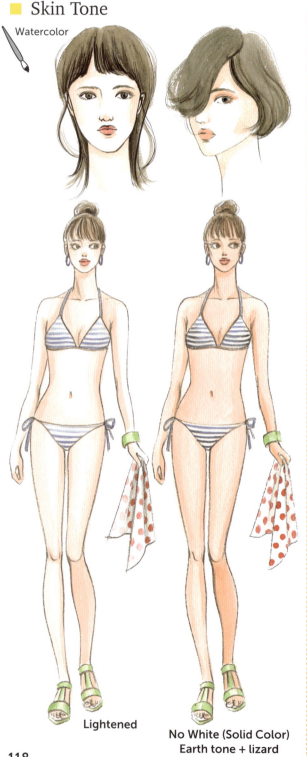
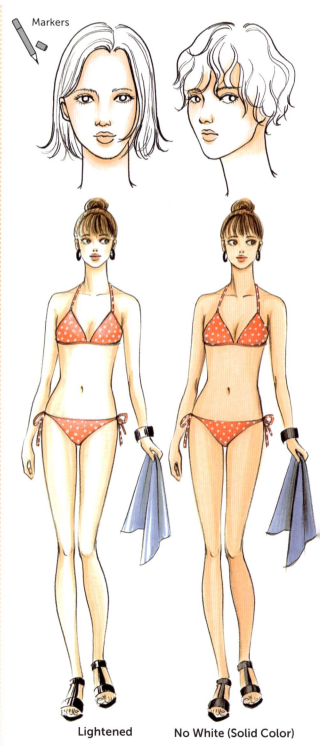

Lightened

No White (Solid Color)
Earth tone + lizard

Lightened

No White (Solid Color)

Except in the case of a single picture that is to be painted slowly and carefully as a work of art, in a situation where coloring is abbreviated to speed up the process, it's more important that the information be conveyed at a quick glance than to focus on a clean finish. Don't be overly concerned about the slightest overhang or unevenness in the paint.

A: The white areas are blurred with a color lighter than the base color.

B: If it's difficult to leave the white color, light can be added later. Paint all the base color once and add light effects with white or similar colored pencils.

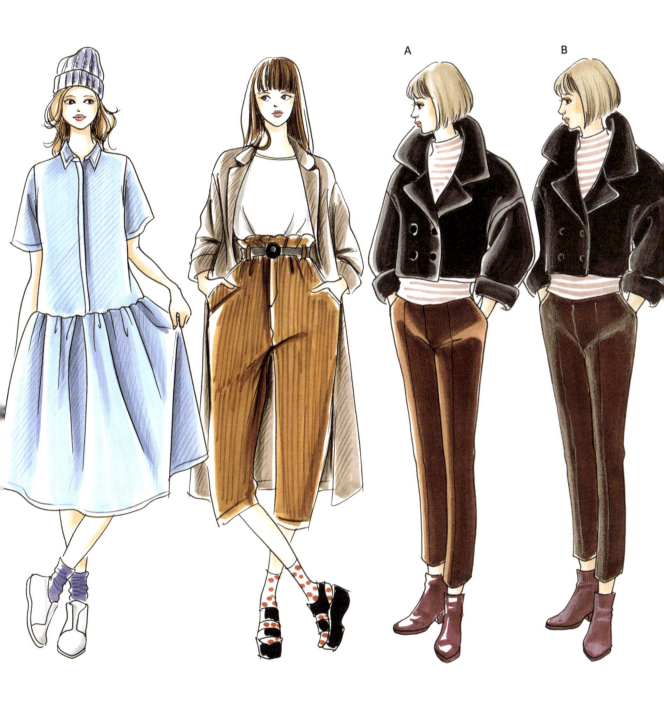

Transparent Watercolors

Watercolors allow for high transparency, enabling the underlying colors to show through even when layered. This creates striking, fresh color overlaps. Blurring and bleeding are easy to achieve, and by adjusting the amount of water, various textures can be created.

Transparent watercolors tend to bleed, and they're not particularly good for adding uniform, solid colors. Opaque watercolors or acrylics are better suited for more even applications.

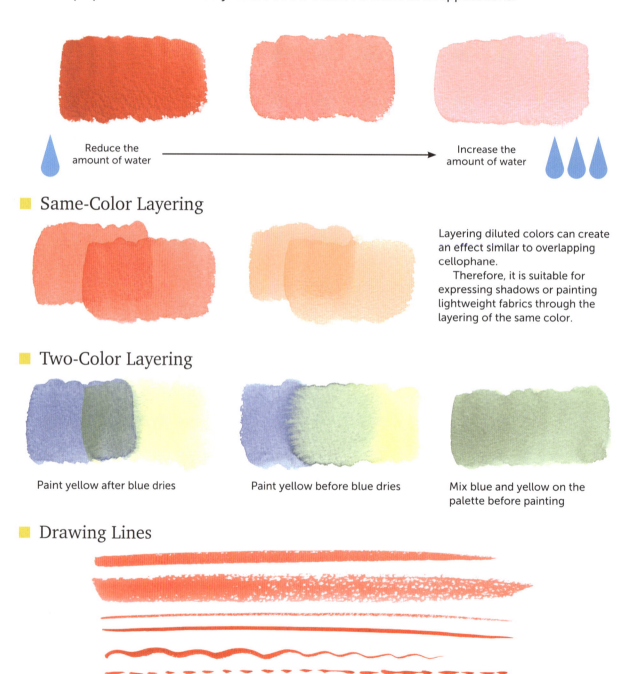

Reduce the amount of water → Increase the amount of water

■ Same-Color Layering

Layering diluted colors can create an effect similar to overlapping cellophane.

Therefore, it is suitable for expressing shadows or painting lightweight fabrics through the layering of the same color.

■ Two-Color Layering

Paint yellow after blue dries | Paint yellow before blue dries | Mix blue and yellow on the palette before painting

■ Drawing Lines

Not only for outlines and structural lines, but also when drawing patterns, thin the brush tip. It's convenient to prepare both soft-tipped and harder brushes together.

Practice Creating Colors

The colors we casually see in daily life are not just vibrant hues; there are also pale, muted, and deep tones and shades. By mixing colors with paint, endless new colors can be created.

"Add a Little Bit of"

By adding a little black or a little yellow, adjust the colors gradually to get closer to the desired hue. Prepare the fabric or a section of a photo and practice mixing colors to match the same color with paint.

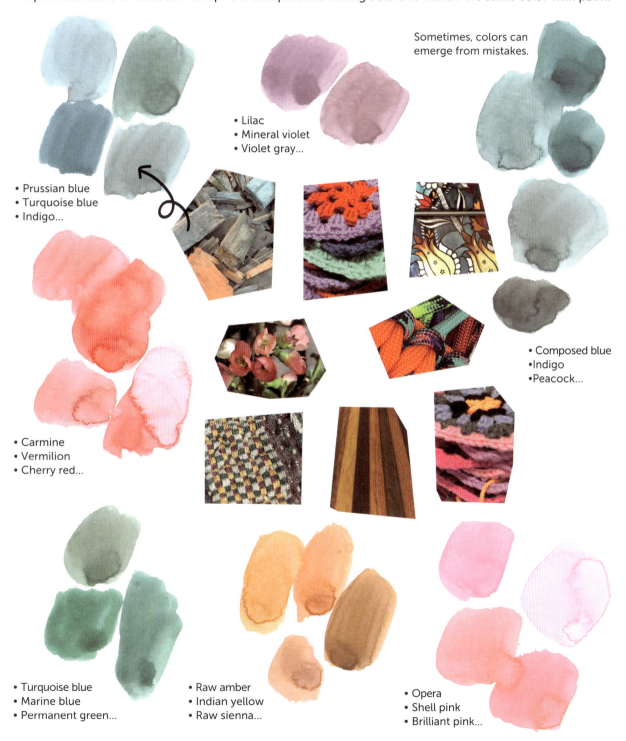

Sometimes, colors can emerge from mistakes.

- Lilac
- Mineral violet
- Violet gray...

- Prussian blue
- Turquoise blue
- Indigo...

- Composed blue
- Indigo
- Peacock...

- Carmine
- Vermilion
- Cherry red...

- Turquoise blue
- Marine blue
- Permanent green...

- Raw amber
- Indian yellow
- Raw sienna...

- Opera
- Shell pink
- Brilliant pink...

121

▪ Techniques for Transparent Watercolor Paint

Blurring
Use a wet brush to spread the paint.

The unique blurring of watercolor is often used to express shadows.

Bleeding
Wet the paper with water only, and then place color onto the wet areas.

This technique can be used for patterns or to suggest materials like fur.

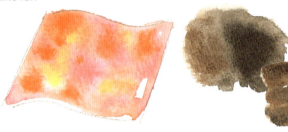

Color Lifting
While wet, or on the areas you want to lift color from, wet the paint and then wipe it off.

This technique is used not only to create materials like faded denim but also to represent glossy areas.

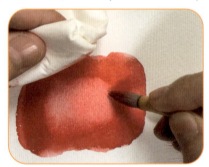

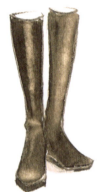

▪ Incorporating Various Techniques

There are many techniques to employ using paint. They can be used to convey the texture and patterns of clothing, or as accents in the background of style illustrations.

Spattering
Rub a fine sieve or a piece of mesh with a toothbrush coated in paint.

Batik
Also known as resist painting, this involves placing paint over a drawing made with crayon or wax on the paper.

Dripping
This painting method involves loading paint onto a brush and letting it drip onto the paper.

■ Expressing the Texture of Fabric

Dabbing
Open the brush tip and hold the brush upright to gently tap it against the surface.

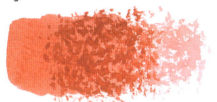

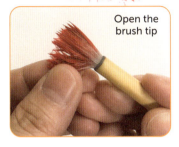
Open the brush tip

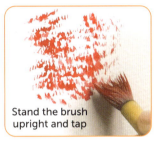
Stand the brush upright and tap

Stretching
Open the brush tip and gently stroke the surface with the brush.

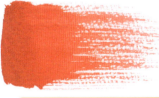

Twisting
Keep the brush tip open and twist the brush while standing it upright.

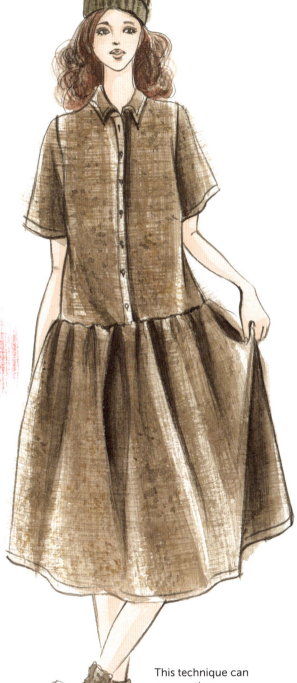

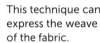
This technique can express the weave of the fabric.

Markers: Features and Techniques

Tips come in various shapes, including square, brush, and round, depending on the manufacturer, so choose according to the situation.

In fashion illustration, the brush tip is often used due to the prevalence of curves.

Markers have the advantages of being quick-drying and providing good color saturation, allowing you to draw with the same color consistently. They're extremely helpful when you need to complete a design in a short amount of time.

They're transparent and allow for layering, making the underlying color visible. With each layer—once, twice, three times, and so on—the color becomes more intense, enabling you to create variations in saturation with just one color. However, they can easily create color inconsistencies, so practice is key to mastering them.

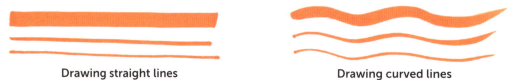

Drawing straight lines　　　　　Drawing curved lines

■ Layering

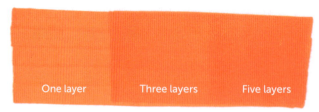

One layer　　　Three layers　　　Five layers

■ Applying Even Color

Color without lifting the pen tip

Coloring in one direction

Lifting the pen tip repeatedly creates overlapping colors and inconsistencies.

If you color in one direction, there will be slight overlapping lines.

In situations where speed is prioritized over process, such as design proposals, you can be less precise about coloring. You can proceed without being overly concerned about minor spills or inconsistencies.

If the inconsistencies are too noticeable, they will draw attention away from the design, so be cautious.

Differences in Touch Based on Pen Tips

The choice of pen tip and the angle at which you hold it can yield a variety of results and effects.

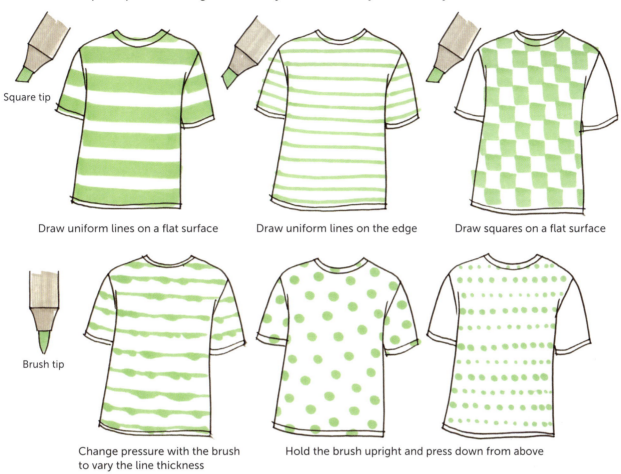

When drawing patterns over a base color, it can help express texture (the base color and the pattern use the same color).

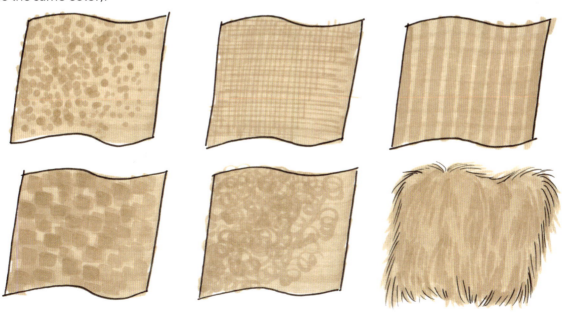

■ Layering Colors

Markers have a limited range of commercially available colors, but you can create new colors by layering them.

However, unlike paint, a lighter color cannot be applied over a darker one.

Markers pair well with other materials, so you can compensate for this by adding lighter colors later using opaque pens or colored pencils.

Colors are layered in the order of ① → ②.

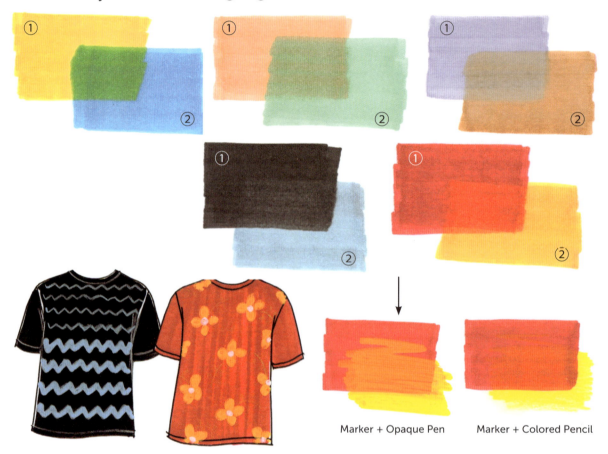

Marker + Opaque Pen Marker + Colored Pencil

Even if the main medium is markers, it's perfectly fine to use other materials in combination.

In the examples above, the opaque pen and colored pencil are used over the markers, but you can also experiment with paints and pastels and see what kinds of effects you can create.

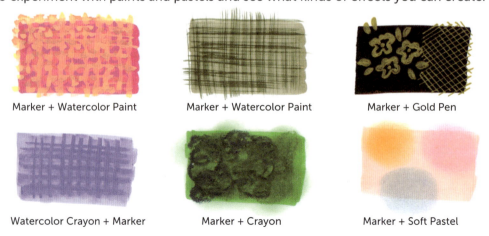

■ Gradient

Using colors of the same hue with a similar brightness makes for a smooth gradient, but combinations that are dissimilar will have noticeable boundary areas. If the boundaries stand out, it's a good idea to blur them with a pencil of the same color.

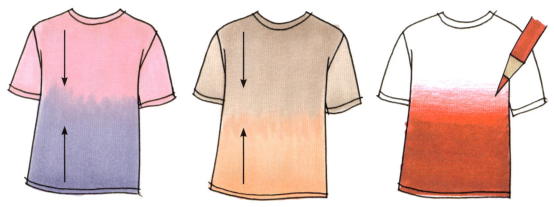

■ White, Black, and Transparency

When capturing fabric, deciding how to color white and black areas can be tricky.
The white of the paper is utilized for items made of white fabric. While black can obscure the underdrawing, you can resolve this by adding lines on top.

White Fabric
Use gray tones for shading. Be careful, as leaving areas uncolored can make it look like you forgot to paint.

Translucent White
If the underskirt is black, painting it with dark gray will give the impression that some areas have a slight white overlay. The key is to leave some white around the edges.

— Dark Gray
— Black

Black Fabric
Apply gray as the base and layer black on top. By leaving gray in the areas that catch the light, the design will be more visible.

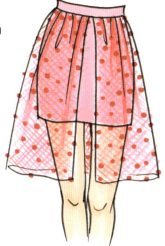

Translucent Fabric
First paint the skin and underskirt, then apply a light color over them.

Black Fabric
Color the entire area with black. Use a white or light-colored pencil to add structural lines and highlights.

Fabric Expression

Painting Materials and Patterns

When clothing and accessories include textures and patterns, the variety of expressions expands significantly. Start by learning how to create style illustrations, adding movement to the patterns to match the fabric.

From the next page onward, transparent watercolor paints will be mainly featured, but the steps remain the same when using markers. When adding lighter colors over darker ones, it's best to use opaque materials or colored pencils.

This mark indicates when markers are used.

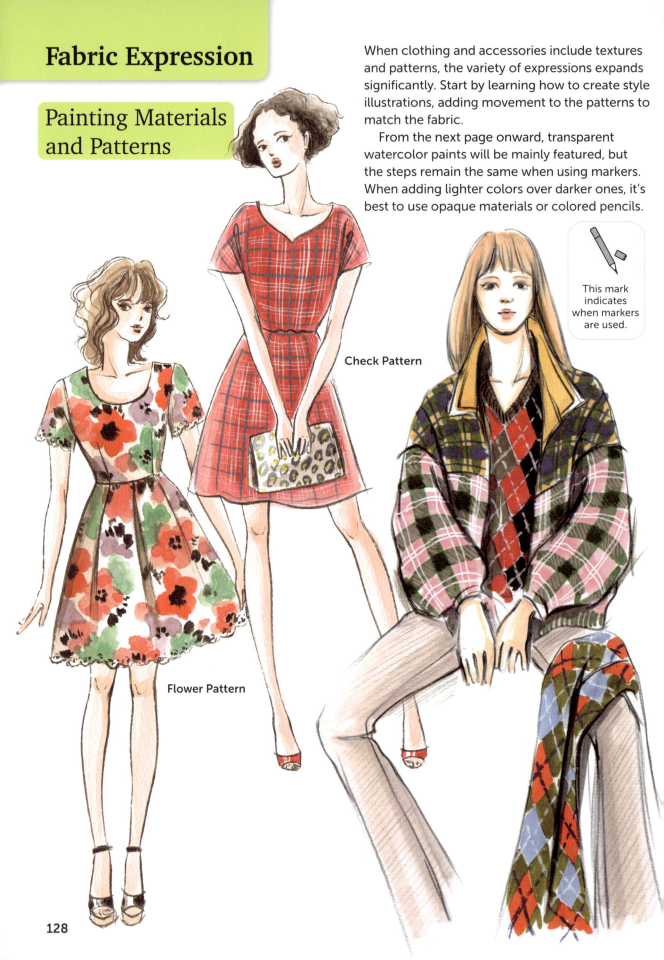

Check Pattern

Flower Pattern

■ Gingham Check

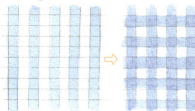
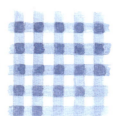

Paint vertically. → Paint horizontally. → Add color where the vertical and horizontal lines intersect to deepen the color.

For check patterns, first draw a grid with a pencil.

■ Curve the pattern to match the fabric's shape.

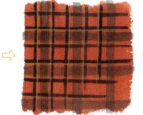

Paint the base color. → Draw the pattern with uniform spacing both vertically and horizontally. → Add fine lines with colored pencils or opaque pens.

The pattern curves to match the folds of the fabric.

Change colors and line widths to create a variety of designs.

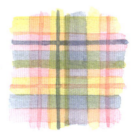

■ Madras Check

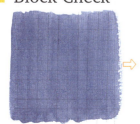
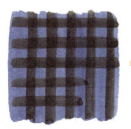

Change the color and paint vertically. → Use the same color as the vertical lines to paint horizontally. → Add fine lines. Color variations.

■ Block Check

Paint the base color. → Add vertical and horizontal lines. → Deepen the color where the vertical and horizontal lines intersect. Color variations.

129

▪ Argyle Checks

 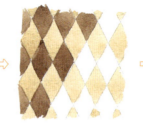 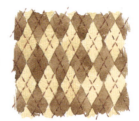 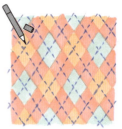

Draw diagonal grids with a pencil and color every other square. → Fill the uncolored squares with another color. → Add dotted lines with colored pencils. Color variations.

▪ Windowpane ▪ Pinstripe ▪ London Stripe ▪ Regimental Stripe

Checkered pattern like window frames. Very thin stripes, like pins. Uniform stripes of the same width. Diagonal stripes.

▪ Polka Dots

When the fabric curves, pay attention to the position and shape of the polka dots.

▪ Floral Patterns

Draw floral patterns. → Add other flowers in between. → Add leaves and stems.

Floral patterns can be of any size, color, or shape. It's fun to think about floral designs that match clothing.

Tie-Dye

Make use of this often kaleidoscopic blurring effect when drawing.

Camouflage Patterns (Basically, it's good to prepare 3–4 earth tones)

 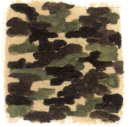 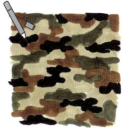

Paint the base color with the first color. | Apply the second color in a scattered pattern. | Add more patterns with dark green or dark brown. | The colors change depending on the environment, like for forest or desert use.

Leopard Prints (Basically, use about three similar tones)

 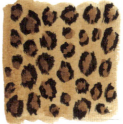

Paint the base color with light brown. | Draw spots with brown. | Outline the spots with black. | Color variations.

Zebra Prints

Draw random curved stripes. | Color variations.

Tiger Print

Snake Print

Giraffe Print

Cow Print

131

▪ Paisley Patterns

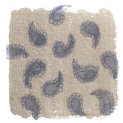
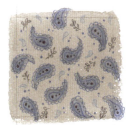

Paint the base color and arrange comma-shaped patterns.

Color the main pattern, then add details.

Add fine patterns, mainly plant motifs, around it.

▪ Denim

After painting the base color, add diagonal lines with colored pencils.

Bleach treatment

Wipe off the paint while it's wet to remove color (page 122).

▪ Quilting

Sketch the machine stitching shape and paint the base color.

Add darker colors to the shadows to create a three-dimensional effect.

Blur the shadow colors and add stitching at the end.

Color variation.

▪ Corduroy

Paint the base color.

Add vertical lines alternately with light and dark colors to create a textured look.

Color variation.

▪ Lace

Draw large wavy lines on the hem part.

Add decorative patterns to the large waves and sketch the lace pattern.

Add details and a fine mesh pattern with thin lines.

Weaves Suitable for Thicker Fabrics

▪ Nep Tweed

 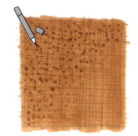

Paint the base color. → Using the tip of the brush, gently stroke to create vertical and horizontal lines, then dab on the paint. → Color variation.

▪ Fancy Tweed

 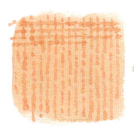 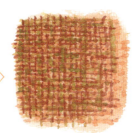

Paint the base color. → Press the tip of the brush lightly and add random lines. → Add more colors. Color variation.

▪ Herringbone

 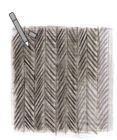

Paint the base color. → Add diagonal lines, changing direction by row. → Overlay dotted lines with a dark color. Color variation.

▪ Houndstooth

 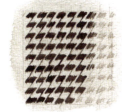 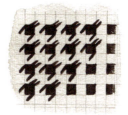 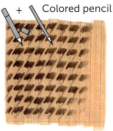

Paint the base color. → Roughly draw parallelograms and connect the top and bottom edges. Pattern variation. + Colored pencil Color variation.

▪ Glen Check

 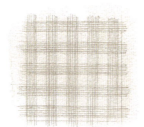 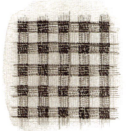 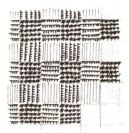

Paint the base color. Draw fine lines vertically and horizontally with a pencil. Add dots. Expanded view of the pattern.

Thick Fabrics

Wool, often used in autumn and winter, is employed not only for jackets and coats but also for pants and skirts. Areas where the fabric overlaps, such as collars, cuffs, and hems, are made thicker.

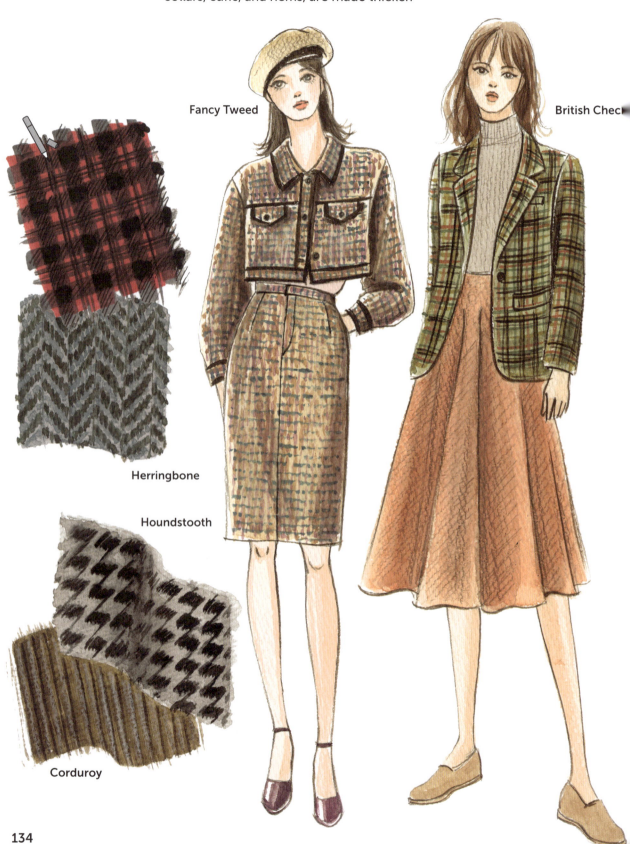

Fancy Tweed

British Check

Herringbone

Houndstooth

Corduroy

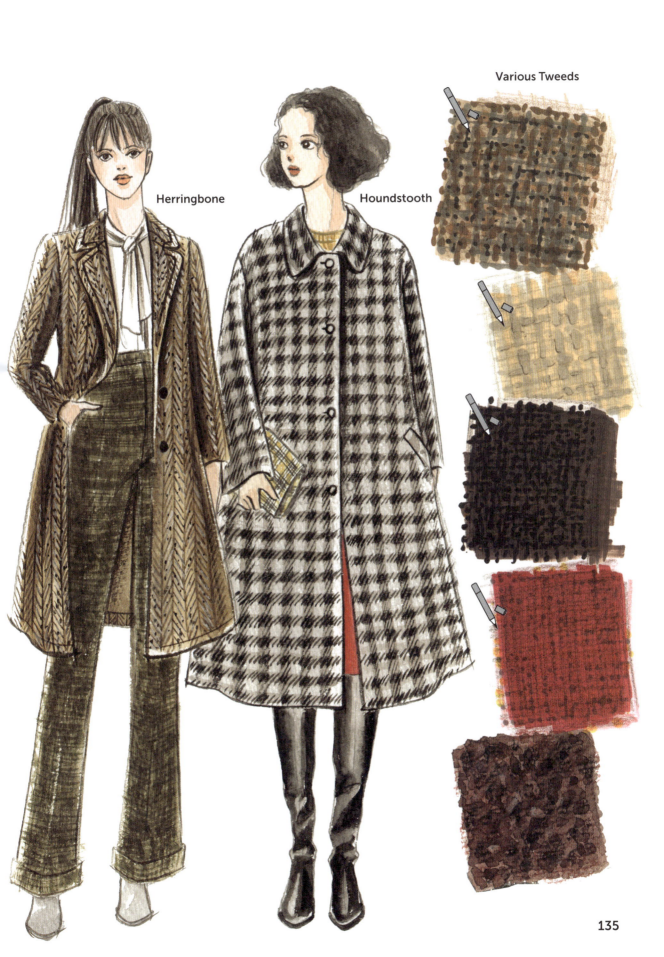

Thin Fabrics

Lace
Depending on the type of lace, some are embroidered, while others have cut-out holes. Many patterns are plant-inspired, with designs repeated at regular intervals.

Chiffon
Thin, soft fabric.

Tulle Lace
Lace fabric made of mesh.

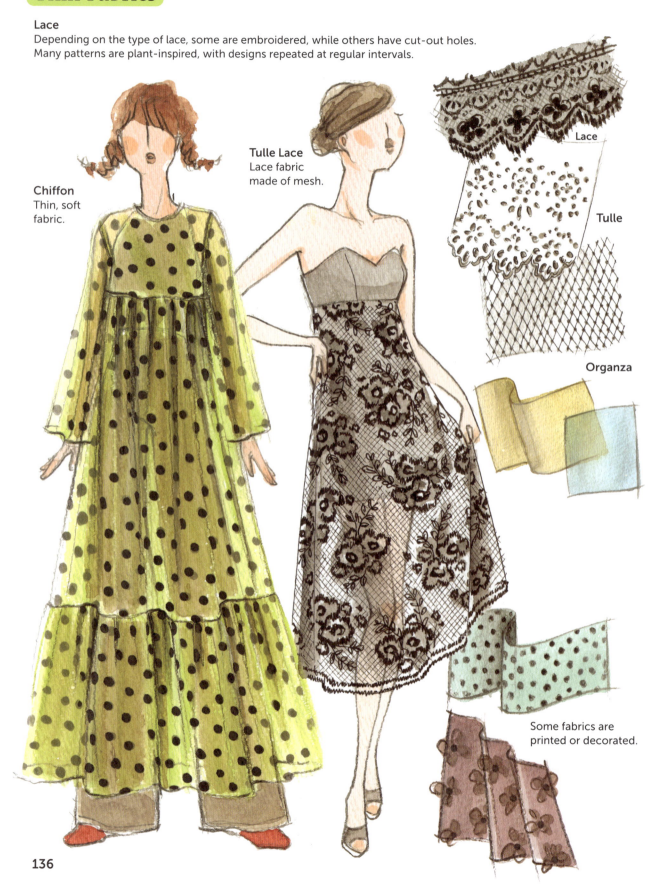

Lace

Tulle

Organza

Some fabrics are printed or decorated.

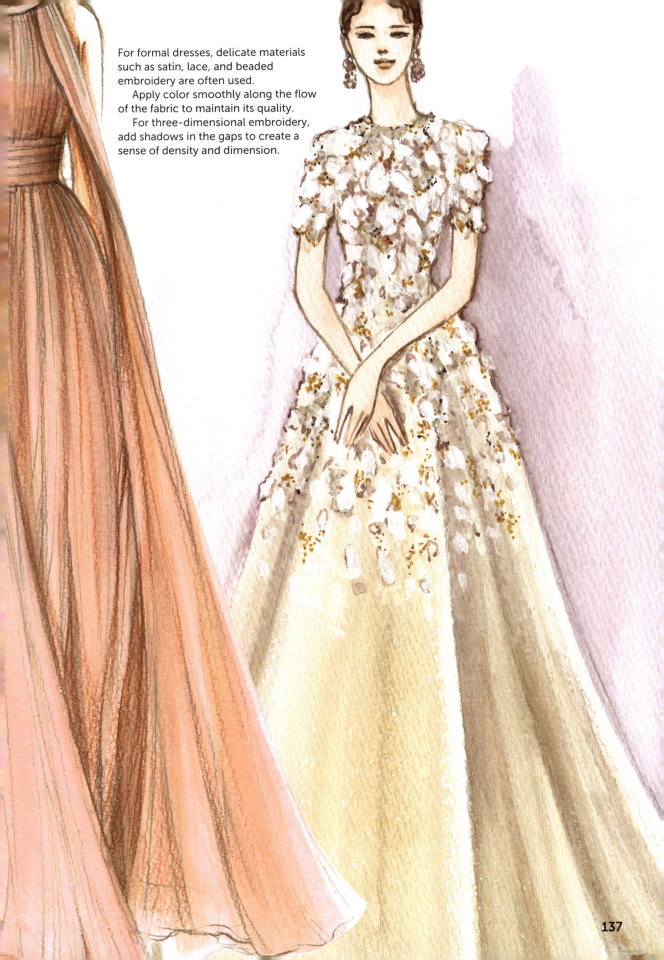

For formal dresses, delicate materials such as satin, lace, and beaded embroidery are often used.

Apply color smoothly along the flow of the fabric to maintain its quality.

For three-dimensional embroidery, add shadows in the gaps to create a sense of density and dimension.

Glossy Fabrics

Clearly distinguish between areas directly touched by light or covered by shadows. There are two approaches: leaving parts unpainted for light or adding light afterward.

Since it's difficult to draw such fabrics from imagination, first sketch real clothing or photos to study how light and shadows interact.

Leather

Watercolor paints
Blur the parts left white afterward.

Leaving the white areas defined enhances the sheen. Ideal for materials like enamel.

Markers
Use 2–3 shades of similar colors to create a gradient.

Add highlights later with colored pencils.

By understanding where light hits and leaving those areas unpainted, you can create a glossy effect.

Watercolor paints
Both transparent and opaque are fine

Leave the glossy areas white.

Blur the parts left white.

Satin, Lame and Sequins

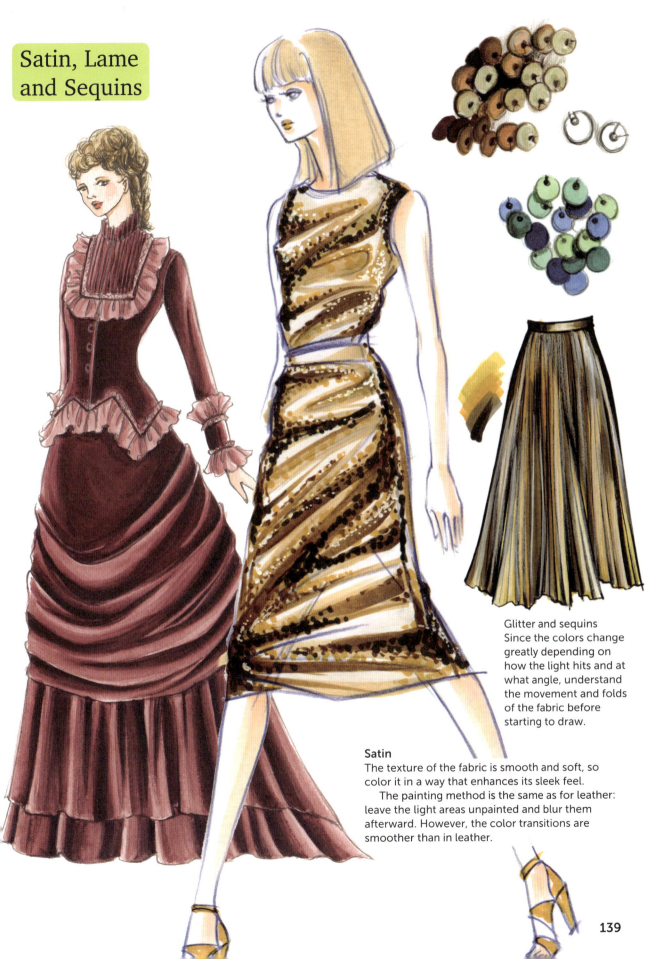

Glitter and sequins
Since the colors change greatly depending on how the light hits and at what angle, understand the movement and folds of the fabric before starting to draw.

Satin
The texture of the fabric is smooth and soft, so color it in a way that enhances its sleek feel.
 The painting method is the same as for leather: leave the light areas unpainted and blur them afterward. However, the color transitions are smoother than in leather.

How to Draw Faux Fur

Fur is characterized by its fluffy thickness. It's important to focus on the brightness of the surface and the depth of the shadows when coloring. When sketching, imagine adding the thickness of the fur on top of the fabric and draw the silhouette accordingly.

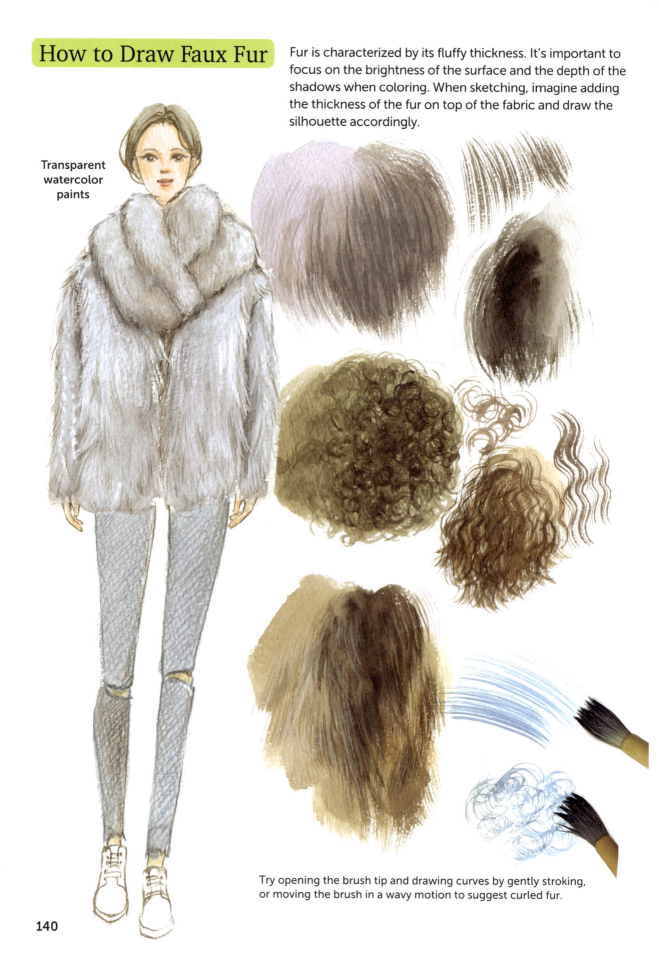

Transparent watercolor paints

Try opening the brush tip and drawing curves by gently stroking, or moving the brush in a wavy motion to suggest curled fur.

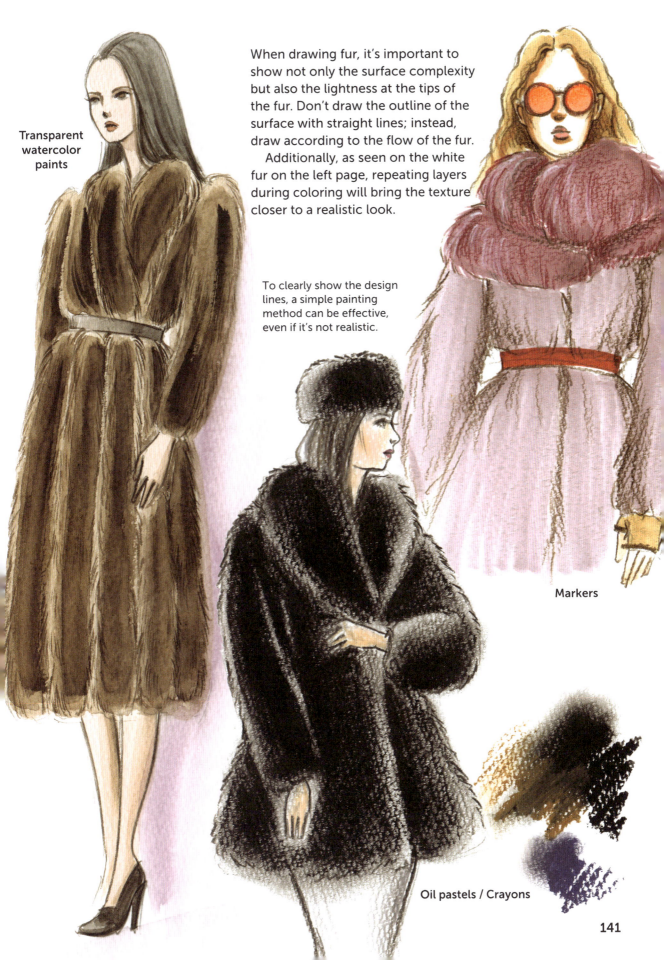

Transparent watercolor paints

When drawing fur, it's important to show not only the surface complexity but also the lightness at the tips of the fur. Don't draw the outline of the surface with straight lines; instead, draw according to the flow of the fur.
 Additionally, as seen on the white fur on the left page, repeating layers during coloring will bring the texture closer to a realistic look.

To clearly show the design lines, a simple painting method can be effective, even if it's not realistic.

Markers

Oil pastels / Crayons

How to Draw Knits

For cable-knit sweaters, you can express the bulge of the knit pattern by adding shadows in the grooves of the knitting. To maintain the softness of the yarn, make sure the outline of the item doesn't have sharp corners.

1

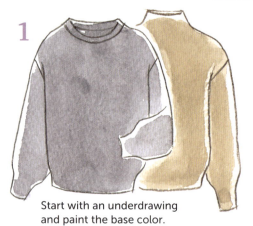

Start with an underdrawing and paint the base color.

2

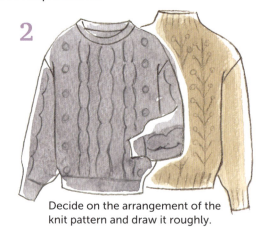

Decide on the arrangement of the knit pattern and draw it roughly.

3

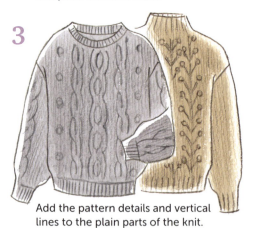

Add the pattern details and vertical lines to the plain parts of the knit.

4

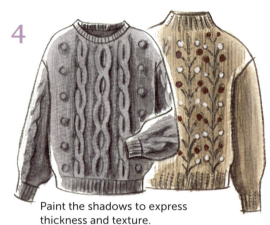

Paint the shadows to express thickness and texture.

Knitting pattern

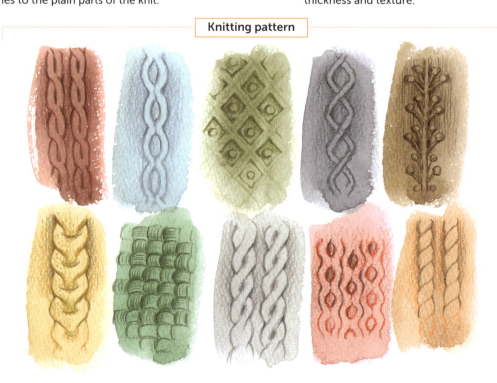

142